IMAGES
of Rail

# BINGHAM CANYON RAILROADS

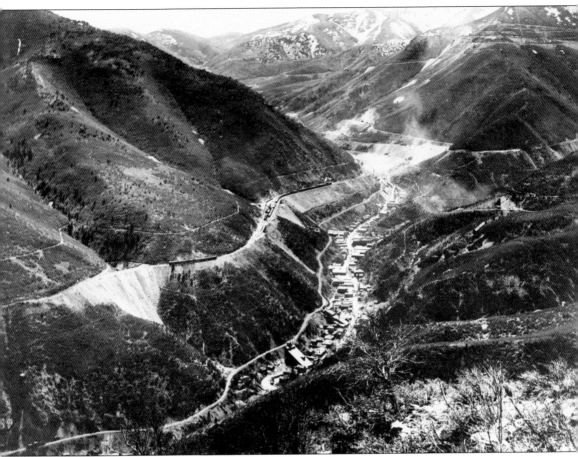

This photograph from April 1907 shows the two rail lines in lower Bingham Canyon. At the bottom of the canyon, just above the town's buildings, is the Copper Belt Railway. High on the hill is Rio Grande Western's low-grade line, which was needed to overcome the steep grades and tight curves of the Copper Belt Line.

**ON THE COVER:** In a scene repeated several times a day from the late 1920s through the late 1940s, a Bingham and Garfield articulated waits for clearance before reversing direction atop the Carr Fork Bridge in Bingham Canyon. The large locomotive has just arrived at the south end of its journey moving a trainload of empty ore cars to the mine from the mills 16 miles north. The scene looks west, up Carr Fork, which was crossed by several high bridges that were used several times a day to move waste material from the mine (at left) to the waste dumps north of the mine.

IMAGES
of Rail

# BINGHAM CANYON RAILROADS

Don Strack

ARCADIA
PUBLISHING

Copyright © 2011 by Don Strack
ISBN 978-0-7385-8489-8

Published by Arcadia Publishing
Charleston, South Carolina

Printed in the United States of America

Library of Congress Control Number: 2011923571

For all general information, please contact Arcadia Publishing:
Telephone 843-853-2070
Fax 843-853-0044
E-mail sales@arcadiapublishing.com
For customer service and orders:
Toll-Free 1-888-313-2665

Visit us on the Internet at www.arcadiapublishing.com

*This book is dedicated to my wife, Joanne, and our daughter, Gina. Without their patience and support over these many years, this book would not have been possible. They have regularly provided ideas and proofreading skills that have only made the effort more complete and useful.*

# Contents

| | | |
|---|---|---|
| Acknowledgements | | 6 |
| Introduction | | 7 |
| 1. | The Copper Era Starts | 9 |
| 2. | Open-Pit Mining | 15 |
| 3. | Bingham and Garfield Railway | 27 |
| 4. | Electric Railroads | 39 |
| 5. | Mill Operations | 71 |
| 6. | Ore Haulage | 87 |
| 7. | Diesel Operations | 101 |
| 8. | Smelter Operations | 115 |
| 9. | Trucks and Shovels | 121 |

# Acknowledgments

My interest in Bingham Canyon railroads started in 1969 while visiting the mine with some model railroad friends, one of whom worked as an engineer on the Ore Haulage Railroad. Right away, I became hooked on the subject. For a very brief four-month period in 1979, I worked as a brakeman on the Ore Haulage Division. The potential publication of a book about Bingham Canyon railroads did not take form until the early 1980s, at which time and with the blessing of certain members of management at the mine and in what remained of Ore Haulage, I was able to visit many of the shops, offices, and work centers at the mine and at the mills. In the 1984–1985 time frame, with the dark clouds of complete shutdown on the horizon, several employee friends saw the need to rescue numerous historically valuable items, including literally hundreds of photographs. Those rescued items, along with a wide variety of additional research, make up the majority of the contents of this book. Several railroad historians, including Steve Swanson, Ken Ardinger, Blair Kooistra, and the late Jim Ozment, helped throughout the years to ensure that I received a steady flow of additional information and photographs. My sincere thanks goes out to all who have helped, whether they are named here or not. The effort has been spread out over many years, but the delays and diversions have all been worth the time it has taken to get this book into your hands.

# INTRODUCTION

In 1979, the head of Kennecott's Ore Haulage Division remarked that the division, as the copper company's private railroad, had surely done its part in "moving a mountain of copper ore." Moving a mountain is literally what has happened throughout the decades between the early years of the 20th century and the early years of the 21st century.

Railroads and mining in Bingham Canyon have gone hand in hand since the first railroad entered the canyon in late 1873. That first railroad was the Bingham Canyon and Camp Floyd Railroad, a three-foot narrow-gauge line that in 1881 became part of the larger Denver and Rio Grande system. In 1890, the narrow-gauge line was converted to standard gauge, a change that allowed both the railroad and the mines that it served to rapidly expand to become the largest and richest mining district in the western United States.

In the early years, the miners were after the gold and silver. As the mines grew, they began mining galena, an ore that was a combination of silver and lead, with traces of gold. The mining of galena ore was the focus of mining operations until the early 1890s, when copper ore became more and more important. America was just starting to use electricity, and to feed that growing market, in the late 1890s and early 1900s, a series of mining company consolidations took place, providing copper wire for America's households and businesses.

In the late 1890s, several mining companies were formed that took copper as part of their name. In 1903, they were joined by the Utah Copper Company, organized to exploit the vast quantities of low-grade copper ore discovered in Bingham Canyon. In 1906, Utah Copper Company, along with Boston Consolidated Mining Company, developed open-cut mining and, with other processes, was very successful in making the mining of the low-grade copper ore a profitable enterprise.

Railroads played an important part in the new open-cut mining method. First, steam shovels would remove the waste material that covered the ore and load it into railroad cars for movement and disposal in other parts of the canyon. As the ore was exposed, steam shovels loaded it into railcars for transportation to the mills, which both Utah Copper and Boston Consolidated had built 16 miles north of Bingham Canyon on the south shore of Great Salt Lake.

At first, the facilities of the Rio Grande Western's Bingham and Garfield branches, along with the Copper Belt Railway, completed in 1901, were sufficient to handle the rapidly growing railroad business. To increase the capacity, in 1907 the Rio Grande Western completed a new line into the canyon, allowing the operation of longer and heavier trains. But the need for capacity soon outgrew Rio Grande's ability to provide service.

To increase capacity, in 1911 Utah Copper organized and built the Bingham and Garfield Railway as a subsidiary to move its copper ore between the mine in Bingham Canyon and the

mills near Magna. The new railroad soon became one of the busiest rail lines in the nation, moving some of the heaviest trains.

In 1923, Utah Copper began converting its steam shovels to be powered by electricity. Within a year, Utah Copper installed electric locomotives at the car dumpers at the mills. Additional cost reductions came when the steam locomotives used in the mine itself were changed to electric locomotives, making Utah Copper's Bingham Canyon mine one the most modern mining operations in the world.

By the end of 1941, Kennecott's Bingham Canyon mine was producing a third of the nation's copper, and the Bingham and Garfield Railroad was setting records by moving more than 100,000 tons of copper ore per day. Also, in 1941, Utah Copper Company became part of the Kennecott Copper Corporation.

As the Bingham mine continued to expand downward, Utah Copper found that it had to move the ore upward out of the mine, only to then move it down the canyon to the mills; this was becoming expensive. To reduce costs, three railroad tunnels were completed between the open-pit mine and the lower portions of Bingham Canyon. The first tunnel was completed in 1944, the second in 1952, and the third (the longest at 3.4 miles), was completed in 1961. A new gathering yard was also completed in 1944 in the lower canyon, further reducing the cost of the Bingham and Garfield Railroad's moving ore cars to the mills.

In 1947, to replace the steam-powered Bingham and Garfield Line, Kennecott completed an entirely new, all-electric, privately owned rail line between the lowest part of the canyon at Copperton and the mills. By this time, the production of ore stood at a daily average of 110,000 tons of ore being moved over the company's own railroad. Traffic on this private railroad was still at this level in 1979 when the electric locomotives were replaced by new diesel locomotives. The electric locomotives in the mine itself were also replaced by diesels, beginning in 1976.

Although not directly part of the railroads in Bingham Canyon, Utah Copper (and Kennecott Copper as its successor) made railroads a vital part of its operations. There were extensive rail operations at the Magna and Arthur mills, as well as connecting rail lines between the mills and the smelter farther west at Garfield. After Kennecott bought the smelter in 1959, railroad operations along the south shore of Great Salt Lake became essentially an in-plant network, connecting each of the components of the copper-production process, including the Garfield copper refinery added in 1950.

From the earliest days, railroads were used to move copper ore, as well as waste rock at the mine. By the early 1960s, Kennecott found that having to maintain a network of electrified railroad tracks was an inflexible and expensive effort. To reduce costs, in 1963 trucks were introduced to move waste rock. By 1966, the upper two-thirds of the mine had been converted to the use of trucks to move both waste rock and copper ore.

In 1983, the entire mine was converted to the use of haulage trucks. Rail haulage was used for reload only, a process that used trucks to move ore to several centralized locations. The largest shovels would then reload the ore into railcars. These reload sites were at the 6040, 5840, and 5490 levels, where there was direct access to the three railroad tunnels. Prior to the end of 1983, there were 42-truck haulage levels and just 11-rail haulage levels. The last reload site, at the 5840 level, was removed in March 2000, allowing the 5840 Tunnel to be closed, bringing to an end the use of railroads in Bingham Canyon. All railroad operations ended in late 2001 when the North Concentrator Complex was closed.

The North Concentrator Complex had as its major components the Bonneville crushing and grinding plant, along with the Magna concentrator, with a slurry pipeline connecting them. Both had depended on rail service when first put into operation, in 1908 and 1966 respectively. Railroads came to Bingham Canyon in 1873, and the shutdown of the North Concentrator Complex in 2001 brought with it the end of Bingham Canyon railroads.

Much more information, including a full bibliography, is available at http://www.utahrails.net/bingham/

# One
# THE COPPER ERA STARTS

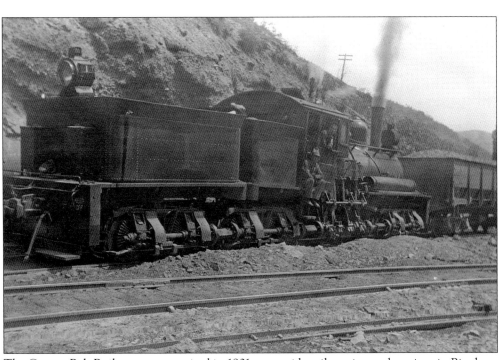

The Copper Belt Railway was organized in 1901 to provide rail service to the mines in Bingham Canyon, connecting with Rio Grande Western's Bingham Branch. It was a standard-gauge railroad converted from an original narrow-gauge, horse-powered gravity tramway built in 1875. By late 1906, five Shay locomotives were operating over the company's tracks in both Bingham Canyon and its spur into Carr Fork.

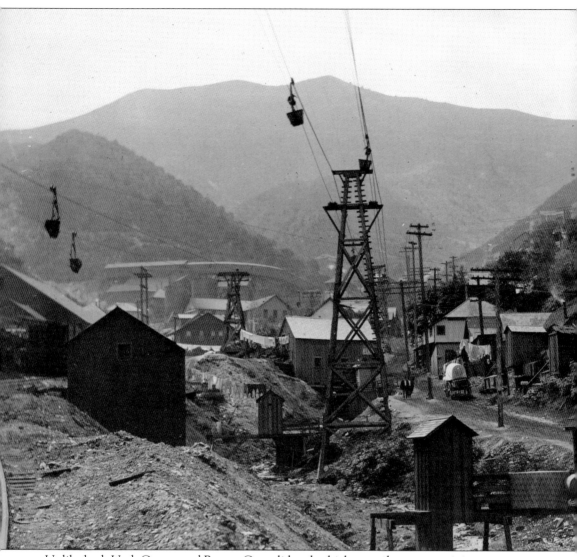

Unlike both Utah Copper and Boston Consolidated, which started open-cut mining seven years before, other mines in the district like the Highland Boy Mine in Carr Fork, shown here in 1914, relied on aerial tramways. The Highland Boy tramway (right) between the mine and Bingham station was 12,500 feet in length and used buckets that each carried 625 pounds of ore. The Utah-Apex tramway is on the left.

The Copper Belt Railway needed more locomotives after completing new spurs in 1903 to serve the ore bins of Boston Consolidated and the Yampa Mine in Carr Fork, along with a spur in lower Bingham Canyon that served the Yampa Smelter. Copper Belt no. 3, a three-truck Shay locomotive weighing 85 tons, was delivered in April 1904.

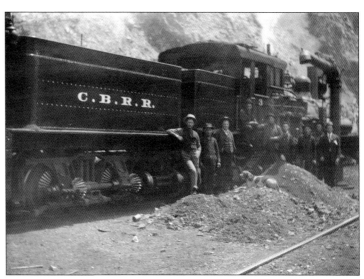

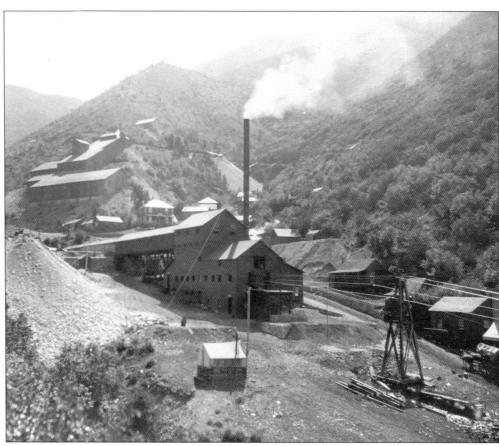

This 1902 view shows the Highland Boy Mine and the upper terminal of the mine's aerial tramway. The mine was owned by the Utah Consolidated Mining Company and was first developed in 1896 as one of the first copper mines. The ore was rich enough that the small quantities shipped along the aerial tramway still allowed the mine to be profitable.

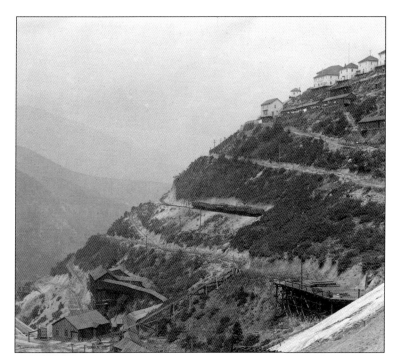

The Copper Belt Railway climbed the south side of Carr Fork to serve Boston Consolidated's sulfide-ore pocket at the bottom of the Muddy Fork side canyon (lower left). The mining company's own Shay locomotive worked the upper switchback tracks that served the levels of their open-cut porphyry mine. The switchbacks were replaced in 1907 by Boston Con's steel-ore bin and incline tramway, located lower in Carr Fork.

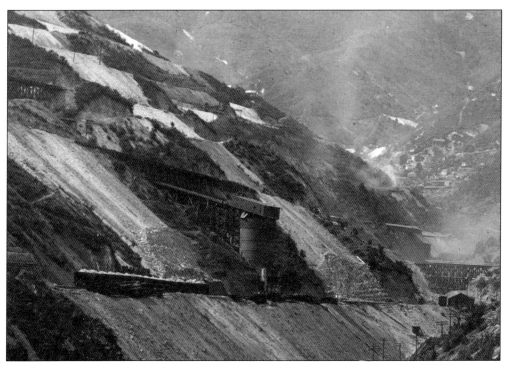

Boston Consolidated completed its steel-ore bin and incline tramway in late 1907, allowing porphyry ore to be loaded directly into cars of the Rio Grande Western. The new ore bin and tramway put an end to the capacity limitations created by the series of severe switchbacks that climbed several hundred feet above the sulfide bins up to the open-cut mine.

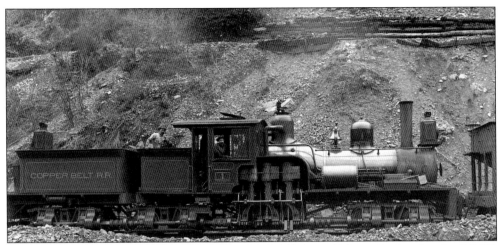

Copper Belt no. 1 was built as no. 7 for J.G. Jacobs's Salt Lake and Mercur Railroad in April 1900. Jacobs almost immediately moved the locomotive to his new operation in Bingham Canyon after he was given a lease to operate the former horse tramway in 1900. In May 1901, the Copper Belt Railway was formally incorporated to operate as a common carrier in Bingham Canyon. (USHS.)

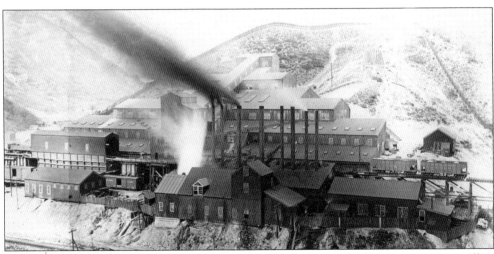

As a test of its new production methods, in 1904 Utah Copper built a concentrator mill at Copperton. Railroad service was provided by Rio Grande Western both for the inbound low-grade copper ore and the copper concentrate that was shipped to one of several smelters in Salt Lake Valley. Note the two all-steel hopper cars (right), which at the time were cutting-edge technology for railroad cars.

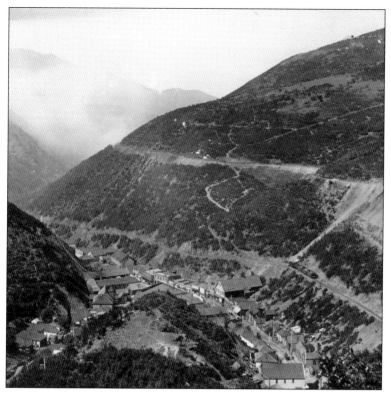

The junction between Carr Fork (lower left) and Main Canyon (lower right) was a landmark location in Bingham Canyon from the earliest days of mining through to at least the early 1950s. This August 1906 photograph shows one of Copper Belt's Shay locomotives slowly moving three loaded hopper cars down the canyon, while high on the canyon wall a shovel is working on the Rio Grande Western's low-grade line.

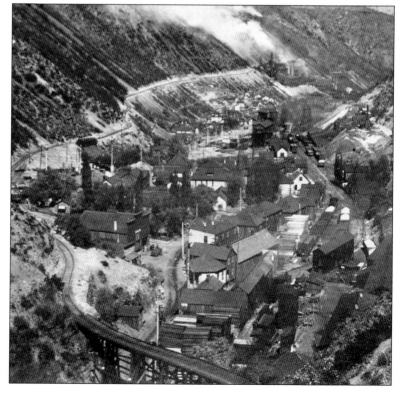

The Copper Belt Railway's spur to the Yampa Smelter is visible in this undated photograph that looks northeast, down the canyon. The majority of the image shows the actual town of Bingham, with the group of railroad cars visible at the upper right showing where Rio Grande Western had its Bingham station. Bingham was where Rio Grande Western connected with Copper Belt Railway.

# Two
# Open-Pit Mining

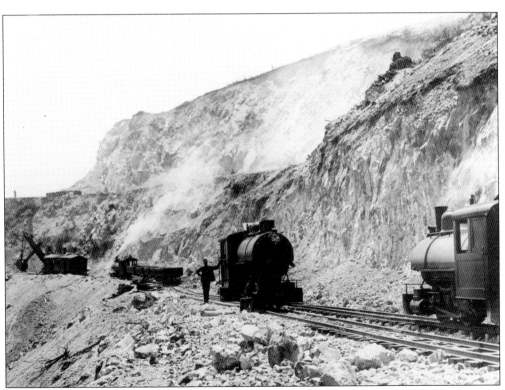

Boston Consolidated started open-cut mining in June 1906, when its first steam shovel started open-cut operations. At the same time, several small narrow-gauge steam locomotives and dump cars were also delivered. By July 1907, a month after the date of this photograph, Boston Con was using four steam shovels.

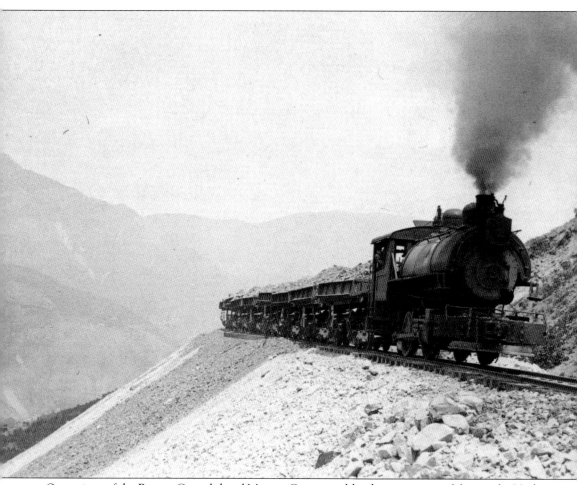
Operations of the Boston Consolidated Mining Company, like the operations of the nearby Utah Copper Company, started using steam shovels in 1906 to remove copper ore and waste material and trains to move the waste material to dumps located in other parts of the canyon. Here a Boston Consolidated locomotive is seen as it works to move a waste train along the highest parts of the company's porphyry mine.

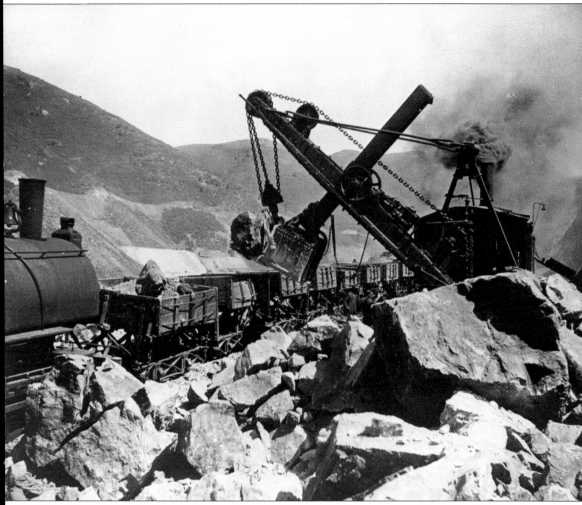

To gain access to the low-grade porphyry copper ore, massive amounts of waste rock had to be removed. After being blasted with explosives to loosen the waste rock, it was loaded by steam shovel into side-dump cars. In the early years, the side-dump cars were wooden, and they were moved using small steam locomotives. At times, it was very large boulders that needed to be moved.

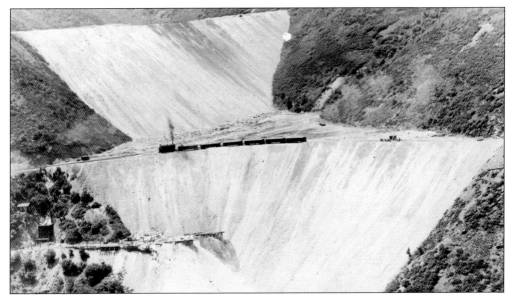

Within a few short years, as operations progressed from the start of open-cut mining in 1906, both Utah Copper and Boston Consolidated began filling in the side canyons and gulches with waste. To allow dumping, surface rights for the various mining claims had to be purchased. This photograph from the 1920s shows one of the gulches on the western side of Carr Fork slowly being filled in.

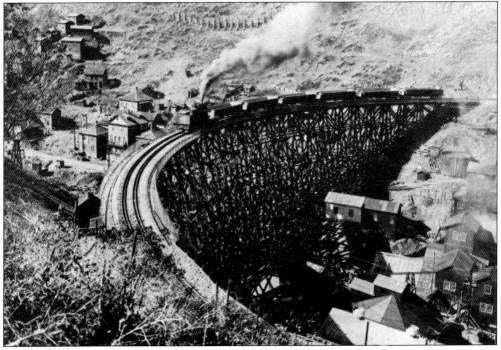

One of several bridges that crossed Carr Fork, the J-Line Bridge was built to allow access to dumping grounds north of the two open-cut mines. Also known as the Yampa Bridge, the J-Line Bridge was located just down the canyon from the Highland Boy Mine, where Sapp Gulch split off of the main part of Carr Fork Canyon.

Living in Bingham Canyon could be hard at times. In the upper reaches of Main Canyon, railroad tracks were built right in front of several of the homes. These rail lines allowed access to the dumping grounds, as well as access to the ore bins of several other mines situated south of the growing Utah Copper open-cut copper mine.

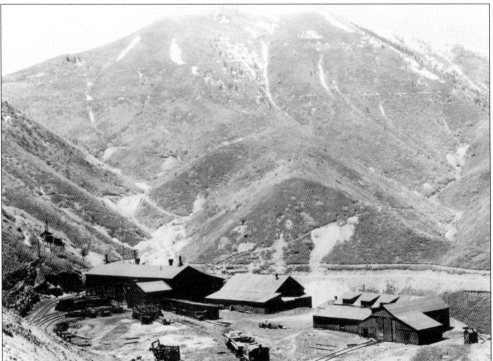

Located at the very top of Carr Fork, the machine shops of Boston Consolidated were an important part of the company's operations. It was here that all of the rail equipment was maintained, as well as the steam shovels. Close examination reveals both narrow-gauge and standard-gauge tracks that were part of the shop complex.

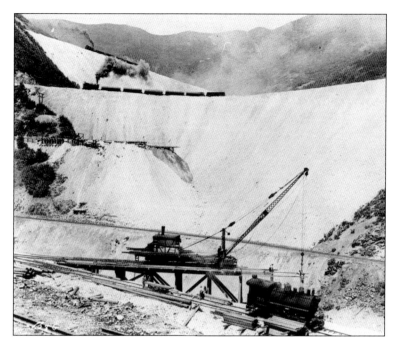

The bridge for the D-Dump Line is shown under construction in this photograph taken in June 1926. The bridge spanned Carr Fork, allowing access to still more empty gulches for the disposal of waste rock. Directly in the background, Cottonwood Gulch is being slowly filled in. The locomotive in the foreground is Utah Copper no. 36, a Porter 0-4-0 built in 1910.

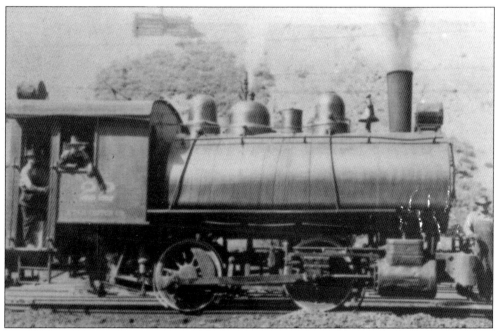

Utah Copper no. 22 was an 0-4-0 built by H.K. Porter in May 1910. It was among a group of 10 identical locomotives delivered to Utah Copper in May to July 1910 just after Utah Copper and Boston Consolidated combined their companies. Each locomotive had 46-inch drivers, and although they weighed 98,500 pounds, they were commonly known as "50-ton" locomotives.

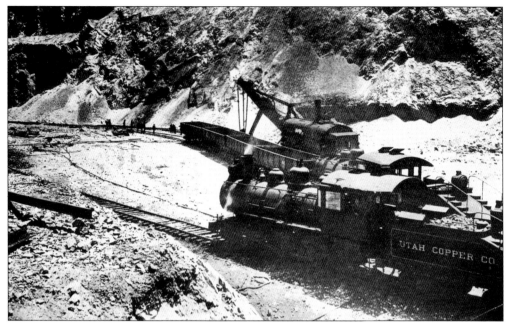

By 1911–1912, and again in 1917, as Utah Copper continued to cut away at the mountain of low-grade copper ore, the company purchased a total of ten 0-6-0 switching locomotives from Baldwin Locomotive Works; all were numbered between 300 and 309. Two locomotives are shown here on the mine's C level, waiting as one of the steam shovels loads more copper ore from the original open-cut mine.

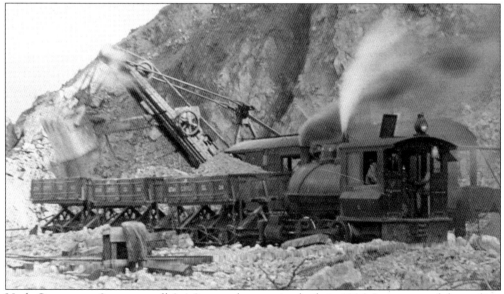

Utah Copper no. 2 was a small 0-4-0 steam locomotive built in 1906. It was one of the earliest steam locomotives used by Utah Copper when the company started its open-cut mining methods. Together with side-dump cars and steam shovels, the use of steam locomotives changed Utah Copper's operations from a traditional underground mining company to a company known throughout the industrial world for its progressive operations.

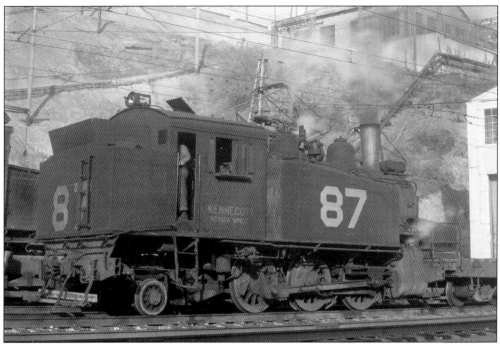

Utah Copper Company used a total of 18 large side-tank locomotives in its Bingham copper mine. They were all of the 0-6-0 (later 0-6-2) wheel arrangement and were built by Baldwin. Utah Copper no. 87 was one of eight delivered in 1923 and 1924. All were declared surplus in 1929 when the mine was electrified, and they were transferred to affiliated open-cut mines in Chino, New Mexico, or Ely, Nevada.

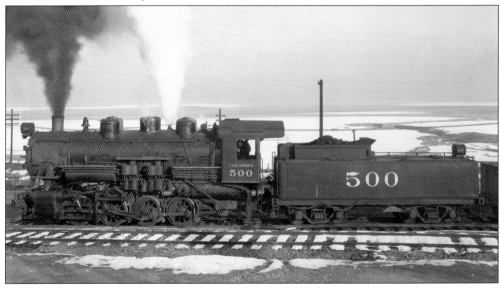

Bingham and Garfield Railway no. 500 was the only 0-8-0 locomotive owned by the railroad. Other than the much-larger articulated Mallet locomotives, no. 500 was the largest of the B&G steam locomotives. It served as the steam example in the motive power tests of 1927 that compared the ability of steam locomotives with the newest oil-electric locomotives (Utah Copper no. 600) and all-electric locomotives (Utah Copper no. 700).

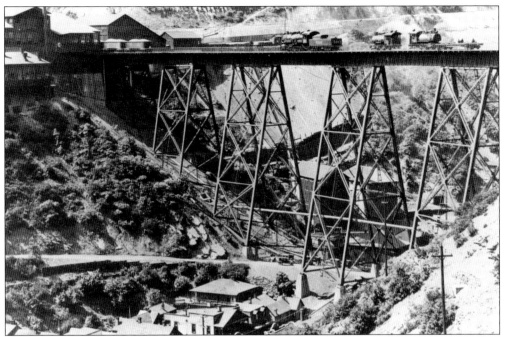

The Carr Fork Bridge was completed in 1911 as part of the Bingham and Garfield Railway, and soon it became a major part of the overall rail operations in the mine. Prior to the dump-line bridges higher in Carr Fork, the bridge served as the sole means for locomotives and cars to move between the mine and the various repair shops and material warehouses.

As operations continued to expand in the 1910–1920 time period, the little 0-4-0 locomotives first used by Utah Copper were found to be underpowered. In 1911–1912, and again in 1917, a total of ten 0-6-0s were delivered to Utah Copper. They worked moving cars filled with copper ore from the mine to the main yard, from which Bingham and Garfield trains then took the ore to the mills.

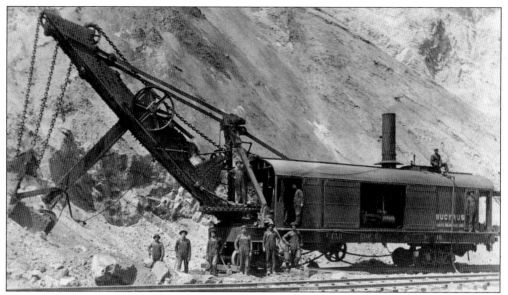

This Bucyrus steam shovel was larger than Utah Copper's earlier shovels, first used in 1906. By the date of this 1914 photograph, Utah Copper owned a total of 22 steam shovels, all of which were mounted to railroad wheel assemblies moving on standard-gauge railroad track laid side by side with the rails used by locomotives and cars as they moved waste rock and copper ore from the mine to the mills.

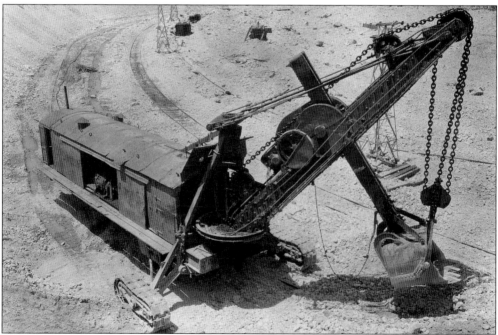

The use of crawler treads on Utah Copper's shovels, starting in 1923, made moving the shovels in the mine a much easier operation. There was no need to install and maintain standard-gauge railroad track that paralleled the tracks of the mine railroad. The combination of crawler treads and electric shovels greatly increased the flexibility of shovel movement, allowing shovels to be moved wherever they were needed within the mine.

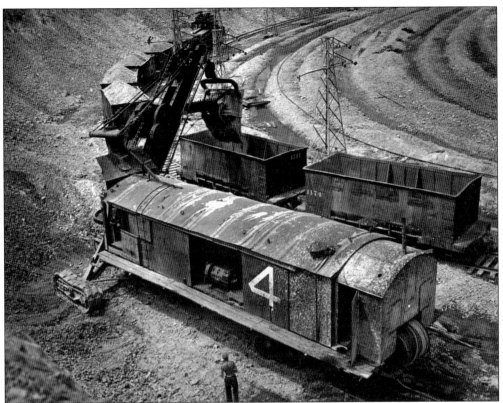

The first electric shovels went into service in April 1923. These first two shovels were also the first shovels mounted on crawler treads that replaced the previous method that used standard-gauge railroad wheels and track. The new electric shovels reduced costs by doing away with maintaining parallel railroad tracks and having to supply the shovels with water and fuel to keep the steam shovels operating.

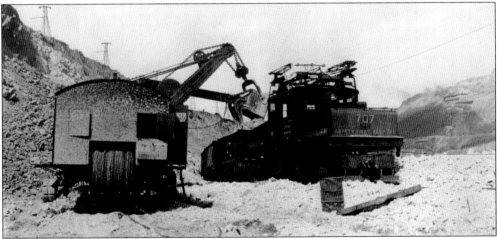

Utah Copper's fleet of steam shovels were converted to electric power in 1923. The electricity was delivered to each shovel by means of a long cable connected to a junction box safely located to avoid damage during normal operations. The excess cable was stored on a large reel mounted to the back of each shovel, as shown in this photograph.

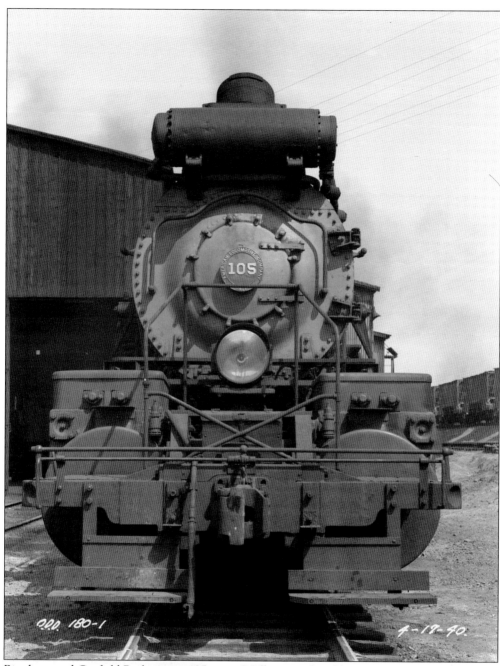

Bingham and Garfield Railway no. 105 was a Mallet articulated locomotive built in 1917. This photograph from April 1940 shows the large Elesco feedwater heater, mounted just ahead of the locomotive's exhaust stack. The feedwater heater used the still-very-hot steam exhausted from the cylinders to preheat water before it was fed into the boiler, increasing a locomotive's efficiency.

# Three
# BINGHAM AND GARFIELD RAILWAY

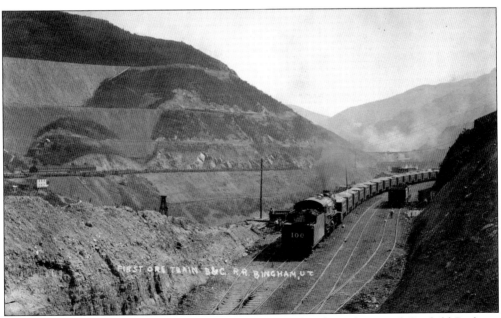

Identified as showing the first train of the newly completed Bingham and Garfield Railway, this photograph also shows the Rio Grande Western's Cuprum Yard, directly across Bingham Canyon from the main B&G Bingham Yard. Both were built at the same elevation that matched the elevation of the Utah Copper Mine located up the canyon. The first B&G train operated between the mine and the mills on September 14, 1911.

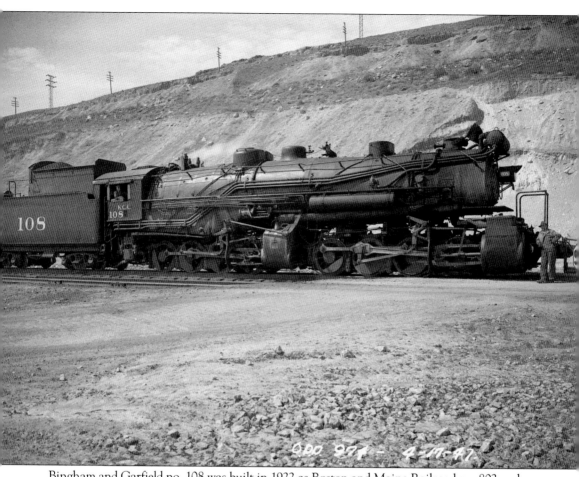

Bingham and Garfield no. 108 was built in 1922 as Boston and Maine Railroad no. 802 and was sold to B&G in June 1929. Shown here in April 1947, it, along with B&G 107, which was built as B&M 801 and purchased at the same time, continued in service to the end of steam operations in April 1948.

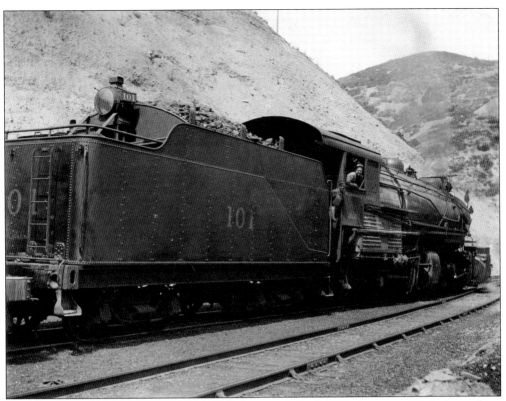

Just three years after operations began, Bingham and Garfield Railway no. 101 is shown here in a photograph from 1914. B&G 101 was delivered in June 1911 but did not enter service until November 1911. All B&G locomotives were fired with coal, and coaling facilities were erected at Bingham and at Magna.

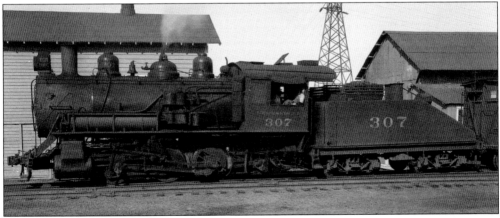

Bingham and Garfield no. 307 was one of a total of 10 locomotives with the 0-6-0 wheel arrangement. All were built by Baldwin Locomotive Works in 1911 through 1917, and all remained in service until the end of steam operations in April 1948. The 0-6-0s were assigned to both Bingham and the switchyards at both Magna and Arthur mills.

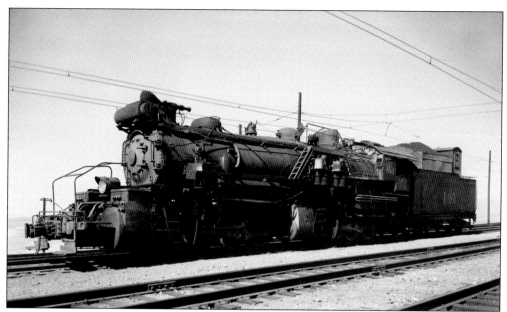

Bingham and Garfield no. 101 came to the railroad in June 1911. When this photograph was taken in April 1947, the locomotive had received several modifications to improve its performance. These changes included larger air pumps for air brakes, a second sand dome for additional traction, and the prominent Elesco feedwater heater mounted ahead of the smokestack used to preheat the water before it entered the boiler.

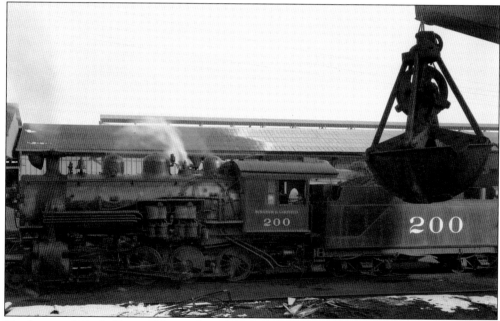

Bingham and Garfield no. 200 was the sole example of the 2-8-0 wheel arrangement on the railroad. Generally assigned as power for B&G's local service, no. 200 helped B&G to act as a designated common carrier to several on-line customers. These included the ore bins of several mining companies, as well as bringing carloads of dynamite from the Hercules Powder plant at Bacchus, midway between the mine and mill.

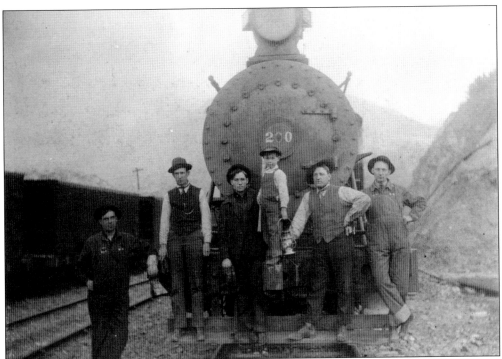

Occasionally assigned as a yard switcher, Bingham and Garfield no. 200, the road's only 2-8-0, worked in the road's Bingham Yard moving both empty and loaded ore cars around as larger trains were assembled for the trip to the mills. The locomotive's crew included an engineer, a fireman, and a conductor (or foreman), along with two switchmen. The young man standing on the coupler may be in training.

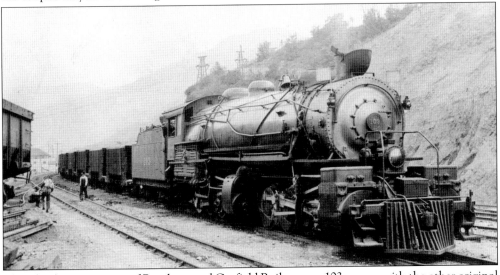

The wheel arrangement of Bingham and Garfield Railway no. 103 was, as with the other original B&G locomotives, an 0-8-8-0, meaning no leading truck, 16 drive wheels, and no trailing truck. This undated photograph shows no. 103 at the head of an ore train that is about to depart from the main Bingham yard. Note the air-operated smoke deflector mounted above the smokestack to deflect smoke while traveling through tunnels.

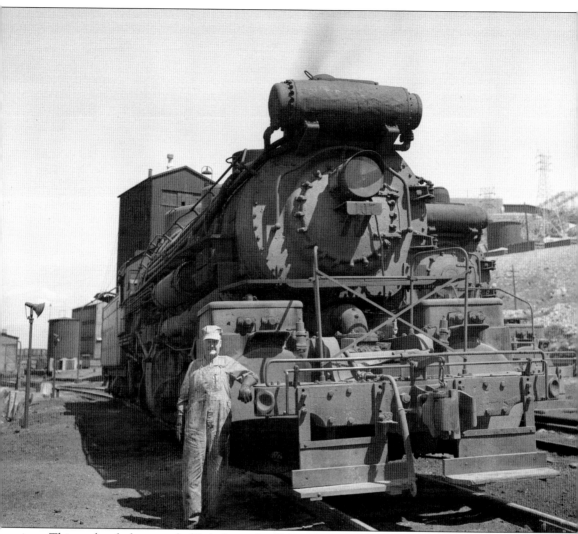

This undated photograph, likely from the 1940s, shows Bingham and Garfield no. 107 at the Magna engine house with its proud engineer. The popular name for an engineer is a "hoghead," named from the days when a locomotive was known as a "hog," supposedly because a locomotive is a big and powerful thing. If that is the case, the B&G Mallets were definitely hogs.

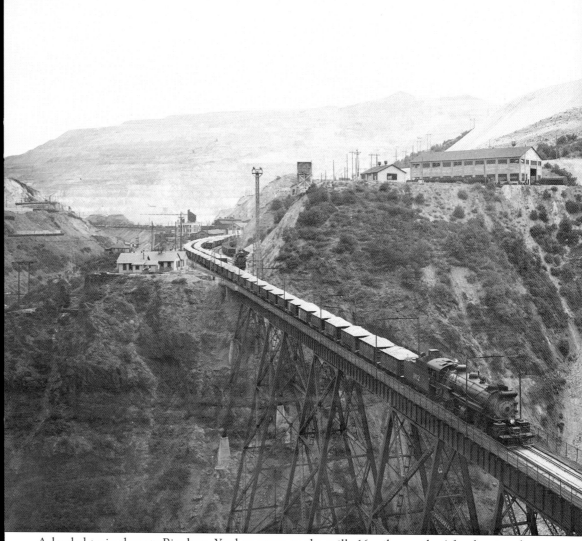

A loaded train departs Bingham Yard en route to the mills 16 miles north. After leaving the main assembly yard, trains immediately moved out onto the spectacular Markham Gulch Steel Bridge. Although the rail line was abandoned in 1949, the bridge itself remained in place until the 1960s, by which time Markham Gulch had been filled with waste.

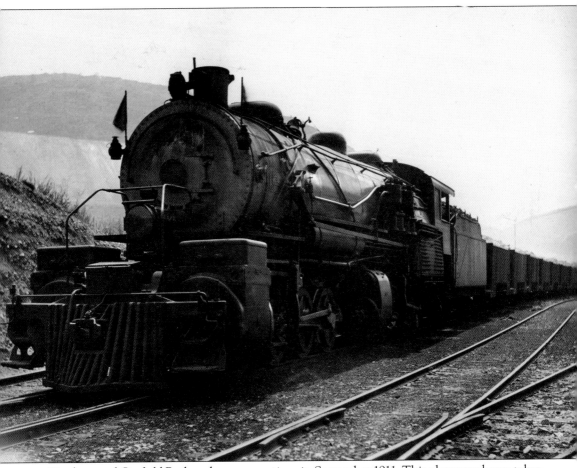
Bingham and Garfield Railway began operations in September 1911. This photograph was taken in 1914 and shows that in the early years, little was done to the locomotives in the way of external changes. The photograph also shows a string of the all-steel ore cars with which the railroad first started operations.

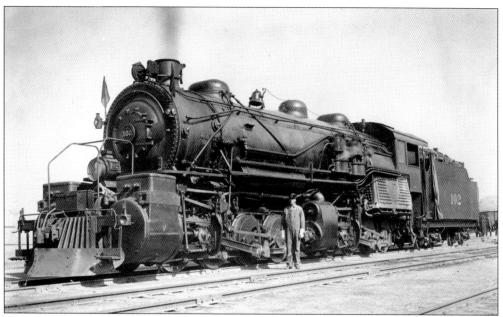

All 11 of the railroad's articulated locomotives were of the Mallet type that first used steam in the rear cylinders before reusing the same steam in the very large front cylinders. This undated photograph also shows that instead of running special large snowplows, the railroad chose to apply sheet metal to the pilots of its locomotives, effectively equipping every locomotive with its own snowplow.

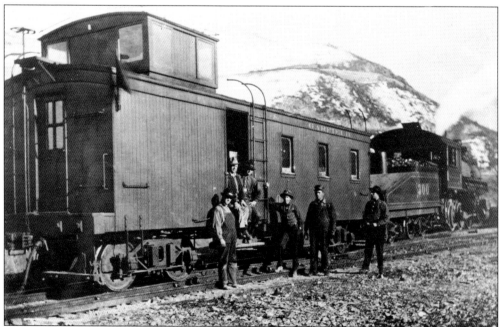

Bingham and Garfield operated a daily freight-mixed train between Magna and Bingham. This photograph shows the wooden caboose that usually operated as part of the daily mixed train with space for both passengers and freight. The caboose is coupled to 0-6-0 switcher no. 300, which was delivered to the railroad in December 1911.

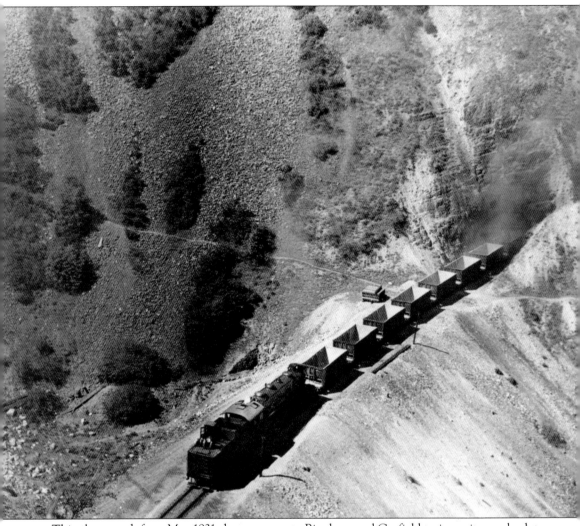

This photograph from May 1931 shows an empty Bingham and Garfield train on its way back to the main Bingham yard. The train is just leaving Tunnel no. 3, and it will soon enter Tunnel no. 4 before crossing the large Markham Gulch Bridge. Like all B&G trains, this train's locomotive is running tender first due to the lack of turning facilities at either end of the railroad.

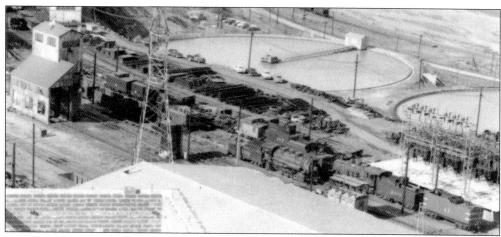

Few records exist showing exactly when Bingham and Garfield retired its steam locomotives. Steam operations ended in late May 1948, but all steam locomotives were retained as standby power for the Copperton electric line. This November 1958 photograph shows several stored steam locomotives, including 0-8-0 no. 500 and 2-8-0 no. 200.

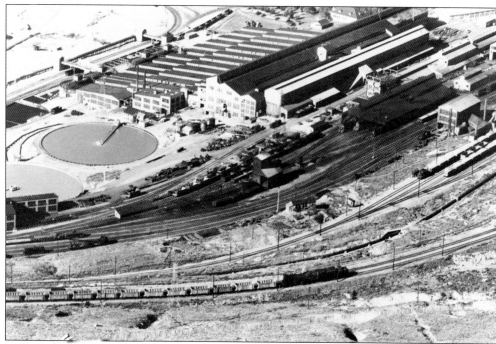

This undated photograph shows the locomotive shops of Bingham and Garfield, located adjacent to the Magna mill. B&G had its own large engine house instead of a more traditional roundhouse. There was also small but adequate coaling tower. Seen at the bottom of the image is one of the articulated locomotives on the Arthur Line returning to the mine with a train of empty ore cars.

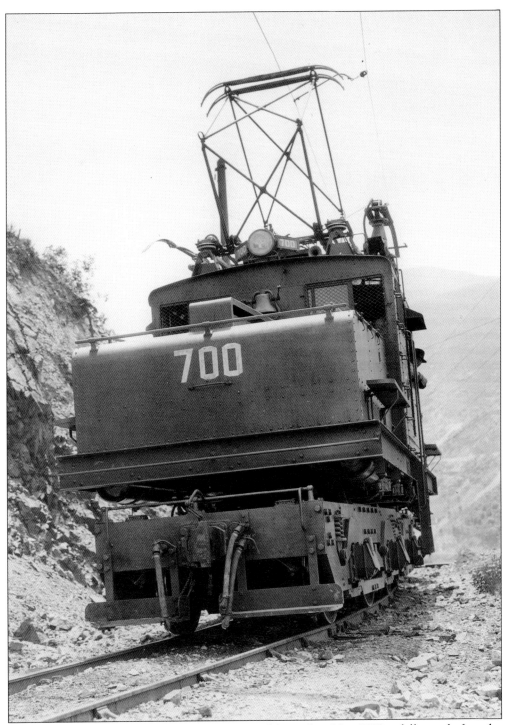

Utah Copper's electric locomotive no. 700 was delivered in May 1927, a full year before the others in the fleet. It was part of a test to determine the best type of motive power to be used in the rapidly expanding open-pit copper mine. The electric design was chosen, and a total of 60 essentially identical locomotives were delivered between 1928 and 1937.

# Four

# ELECTRIC RAILROADS

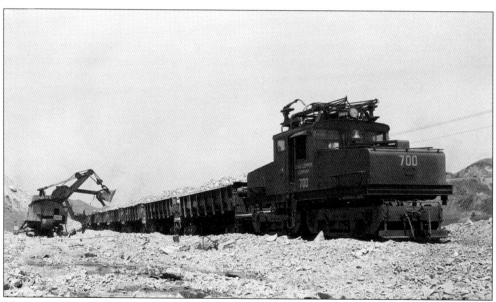

The motive power tests of 1927 included no. 700, as well as steam locomotive no. 500 and oil-electric locomotive no. 600. No. 700 was used in waste-train service to test the "extension cord" feature shared in later years by several of the electric locomotives. This allowed the electric locomotives to operate away from the overhead catenary wires.

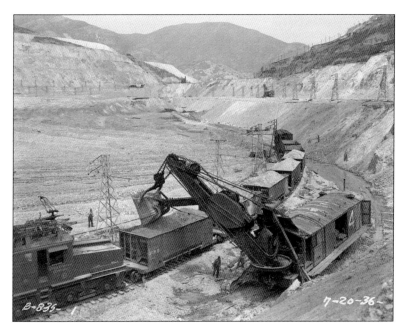

By mid-1936, Utah Copper's open-cut copper mine had expanded beyond its initial terraces of the original mine to the beginnings of the open-pit mine that continued to grow. This photograph was taken in July 1936; the view looks almost due north and shows that the mine had already transformed the original canyon.

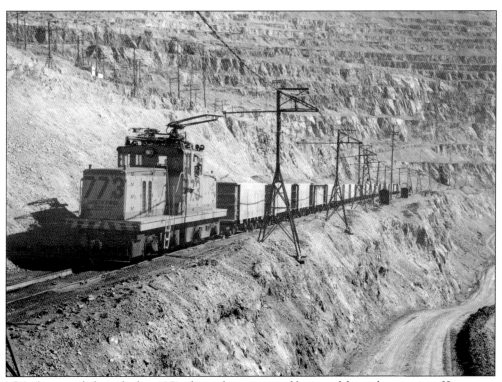

This photograph from the late 1950s shows the newest and largest of the pit locomotives. Kennecott no. 773 was delivered in November 1955 as part of the expansion program that included the three-mile-long 5490 Tunnel, which itself was completed in early 1959. Note the side-arm pantograph that allowed the pit locomotives to use catenary wires located to the side of the tracks away from shovel-loading operations.

Utah Copper no. 711 was among the initial group of 20 locomotives delivered in September 1928 through February 1929. No. 711 had just been delivered in January 1929, the date of this photograph, which also shows the deployment of newly designed side-arm pantographs. This locomotive was also equipped with a cable reel under the frame to allow operations away from the overhead catenary.

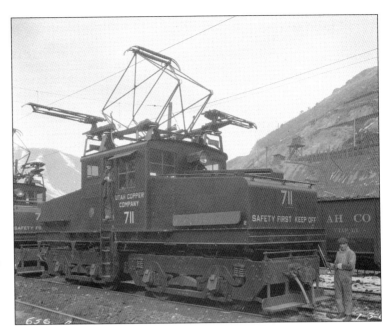

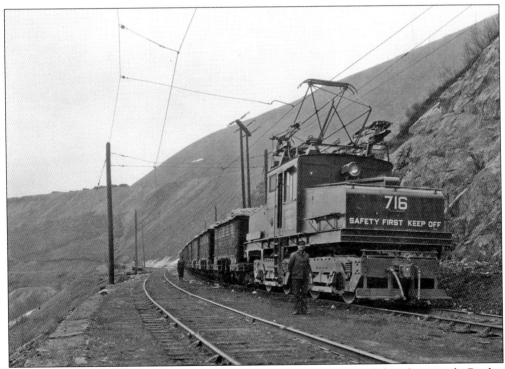

Mining operations were expanding rapidly by March 1929, the date of this photograph. By this time, the entire mine had been electrified, and costs to extract waste rock and ore were being reduced. Utah Copper no. 716 is shown at the head of an ore train as it makes its way along the F level, just above Utah Copper's main yard.

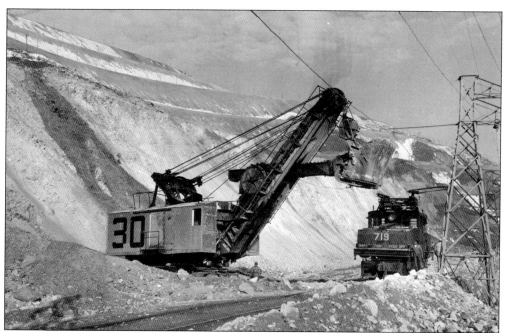

Side-arm pantographs on Utah Copper's electric locomotives allowed the overhead catenary wire to be located to the side of the track, away from possible damage by shovels as they loaded the trains. By the condition of its exterior, shovel no. 30 was recently delivered, and this photograph was possibly a test to show the needed clearances between dipper and locomotive no. 719.

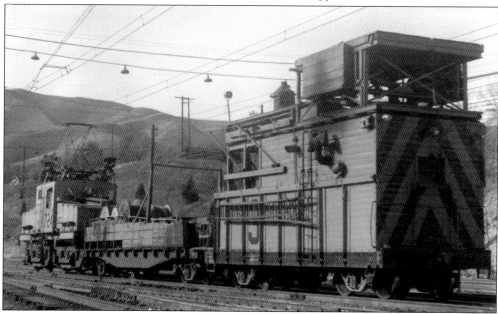

The overhead wire used by locomotives throughout the Bingham copper mine required constant maintenance. In this late-1965 photograph, Kennecott no. 724 is moving a flat car loaded with spare wire and catenary parts, as well as one of the specialized line cars. These special line cars were equipped with a platform on the top of the car that could be raised to gain direct access to the overhead wire.

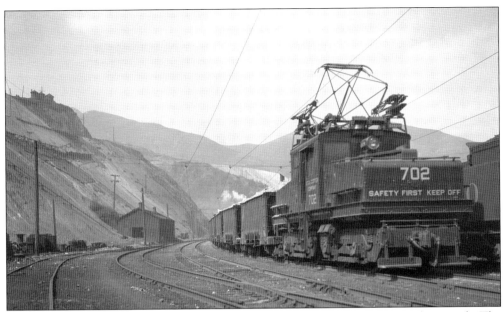

Utah Copper no. 702 was just a month old by the time of this October 1928 photograph. The locomotive is shown in the main Bingham assembly yard, known as the auxiliary yard, where loaded ore cars were assembled into trains to be moved across the Carr Fork Bridge to Bingham and Garfield's main yard.

There was no copper ore along the east side of Bingham Canyon. To allow access to the body of ore at lower levels, Utah Copper was forced to begin the removal of increasingly large amounts waste rock on the east side. This photograph, looking north, shows trains being loaded with waste rock on the east side, which would in turn be moved to areas outside of the canyon for disposal.

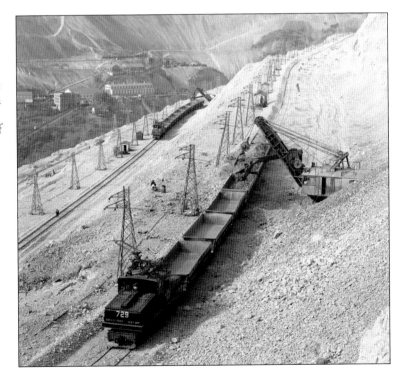

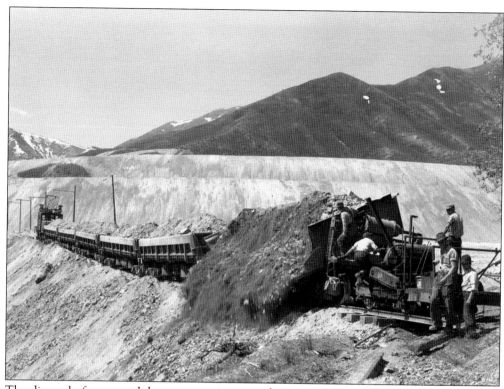

The disposal of waste rock became a major part of mine operations. Using side-dump railcars, entire trains of waste rock were moved away from the mine as it continued to expand. The waste trains were dumped in areas away from the main canyon, including several side canyons and gulches. This train is shown dumping its waste material in one of the side canyons north of the main canyon.

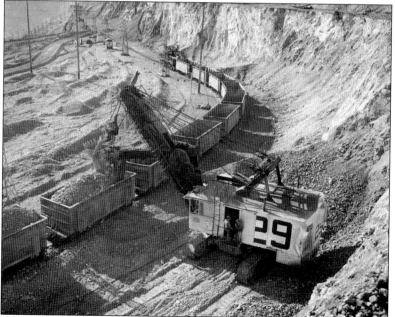

Kennecott shovel no. 29 was a Marion model 151-M electric shovel, built in 1977. The shovel received its power by way of heavy cable laid along the ground. Each cable was in turn connected to a large junction box located adjacent to the tracks, similar to box no. 58 at the upper left.

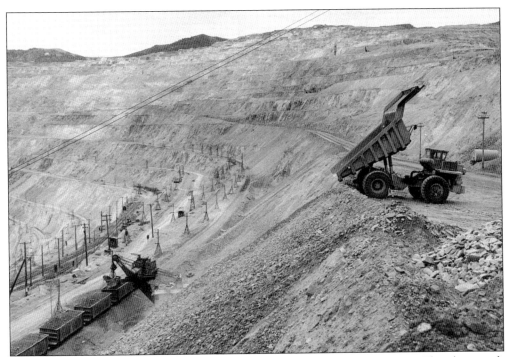

Kennecott Copper started using large trucks in the Bingham Canyon mine in 1963. This photograph from the late 1960s shows what became known as "reload" operations, in which copper ore was loaded into trucks. The trucks then dumped the ore at locations above railroad tracks. The ore was then loaded by larger shovels into railcars.

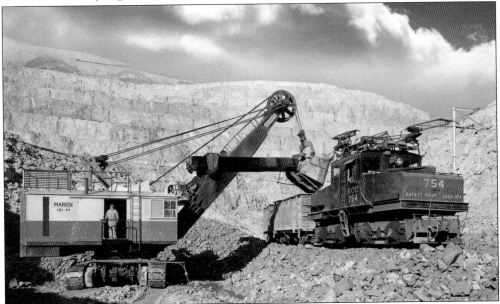

In this photograph from the late 1950s, Kennecott electric locomotive no. 754 waits while shovel no. 1 loads its train. Locomotive no. 754 was delivered in April 1937. Kennecott shovel no. 1 was an electric Marion model 151-M, delivered to the Bingham mine in August 1954. The capacity of its dipper bucket was eight cubic yards.

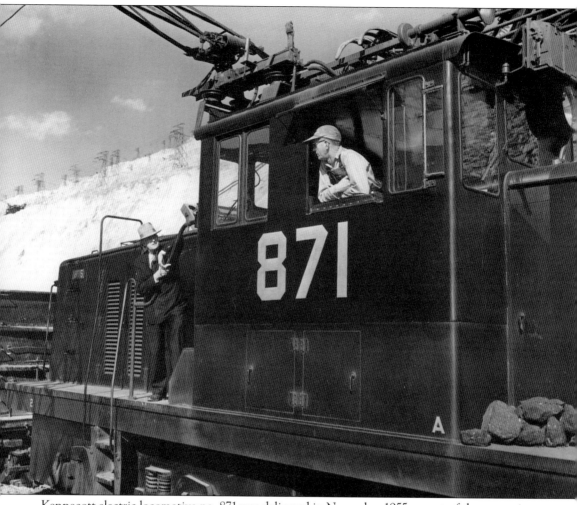
Kennecott electric locomotive no. 871 was delivered in November 1955 as part of the expansion that included the 5490 Tunnel at the bottom of the Bingham pit. Work began on the tunnel in late 1956 and was completed in early 1959. The 5490 Tunnel was at the very bottom of the mine for almost 10 years.

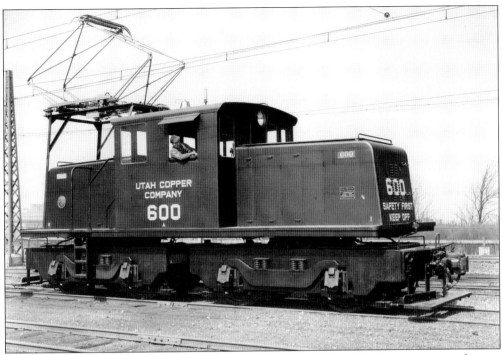

Several new locomotives were delivered in 1942, as the Bingham mine was increasing production to meet the demands of World War II. The new locomotives were numbered 761 through 764. In addition, the new delivery included Utah Copper no. 600, which was assigned to dumper service at the mills, joining six others already assigned to the mills. The new locomotives were needed to match the sudden growth in demand as mining and mill operations were improved and modernized. The improvements included increased capacity, which in turn meant more ore needed to be moved and processed at the mills. No. 600 was reassigned to the mine in 1948 when the new Copperton Line was put into service and renumbered to no. 665. In late 1965, it was renumbered again, to no. 765. No. 765 was retired and scrapped in 1983.

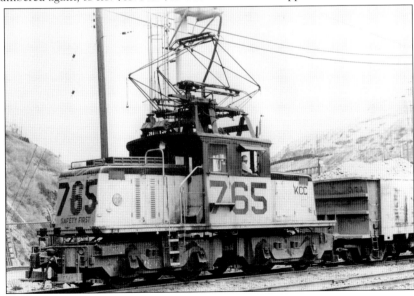

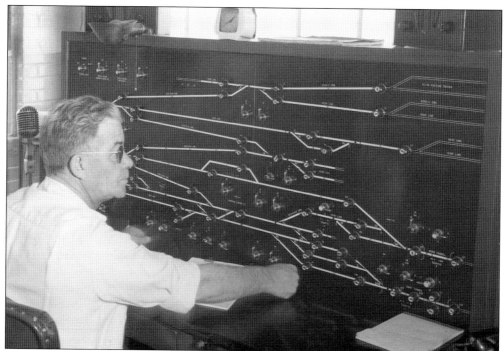

To gain more sites to dispose of its waste rock, in 1926 Utah Copper bought the original RGW High Line (completed in 1907) and began using the line, along with additional spurs, to move waste trains to dump sites outside of Bingham Canyon. At first, flagmen and manual switches were used to control train movement. By the 1940s, as wartime traffic continued to make operations difficult, General Railway Signal Company (GRS) was asked to furnish a way to control trackside signals and sidings. These two GRS NX-type machines were part of the solution. The photograph below shows the board for the dump-line trackage higher on the mountain. The board in the photograph above shows the connecting lines between the 6040 Tunnel and the new CC yard that connected with the Bingham and Garfield Line to the mills.

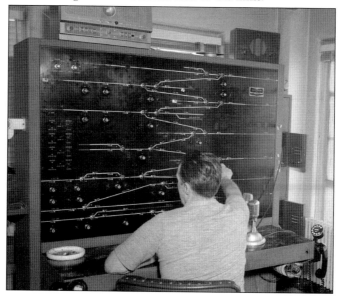

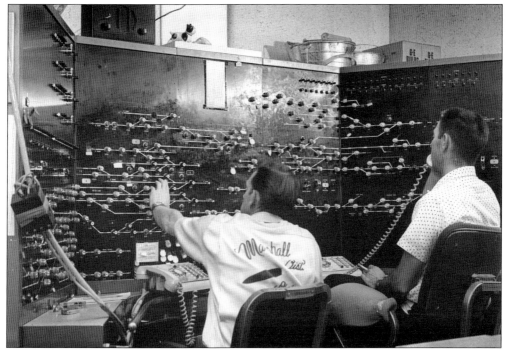

In 1958, the two GRS NX traffic control boards, along with a third GRS board that controlled the dump lines above Upper Bingham and Copperfield, were combined to create the new control board shown in this photograph. Using two operators, the new control board consolidated in a single location the three earlier boards from three locations and the work of three separate operators.

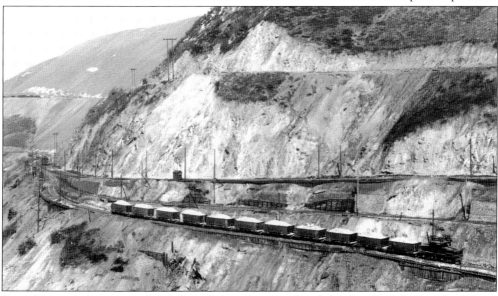

Directly across the canyon (east) from the auxiliary yard and the Carr Fork Bridge, the C Line was the highest track that extended from the open-pit mine around to the eastern side of the mine. This March 1929 photograph shows loaded ore cars being moved along the C Line, from the mine and through A–C Junction and then down a series of switchbacks to the former D&RG Cuprum Yard.

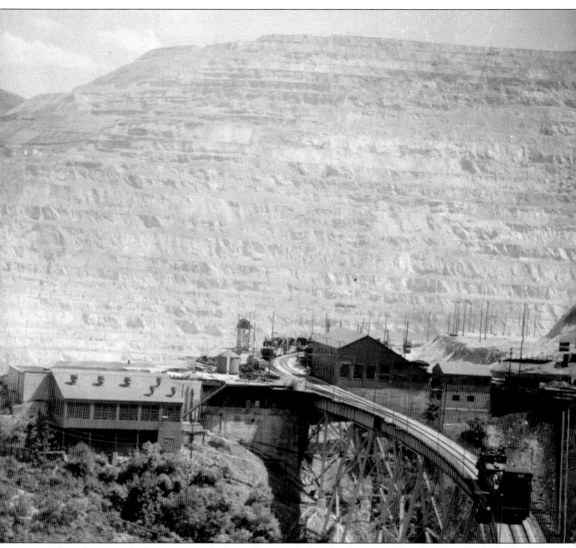

This photograph shows a view looking due south. In the foreground is the Carr Fork Bridge. In the center are the main shops of Utah Copper. In earlier times, adjacent to the shops was the company's main yard. By the time of this undated photograph, the yard had been removed, as well as the mountain itself. In the distance is the far south side of the open-pit mine.

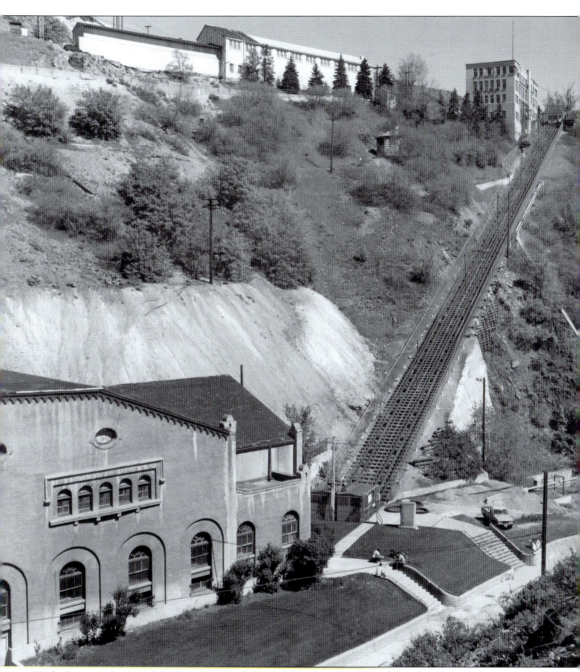

With the completion of the Bingham and Garfield Railway in 1911, the railroad needed a way to get paying passengers from the town of Bingham up to the newly completed railroad's Bingham passenger station. An incline tramway was completed to move patrons from the Gemmell Building (lower left) up to the depot that was adjacent to the mining company's offices, located in the three-story building shown at the upper right.

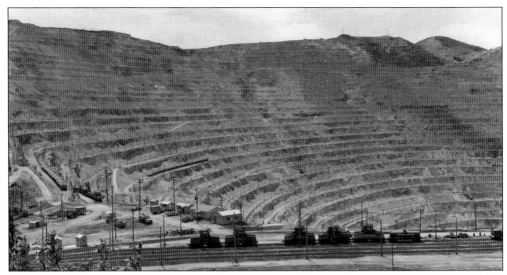

By the early 1950s, the new 6190 Yard had been built as an assembly point for ore trains that would then exit the mine by way of the 6040 Tunnel. Perched on the northern rim of the pit, the 6190 Yard became the focal point for operations, and as late as the mid-1970s it was where crews parked their private automobiles and boarded their assigned locomotives.

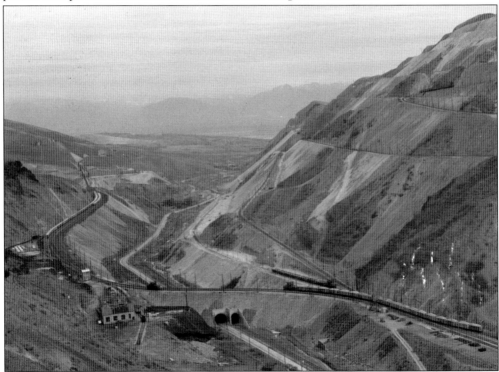

This October 1946 photograph of lower Bingham Canyon shows the C-C Line that crossed the canyon from south to north. To the right, a train of loaded ore cars has left the 5840 Tunnel and is crossing above the highway and the D&RGW Bingham Branch. To the left is the new Central Yard, where electric mine locomotives interchanged loaded and empty ore cars with the Bingham and Garfield steam locomotives.

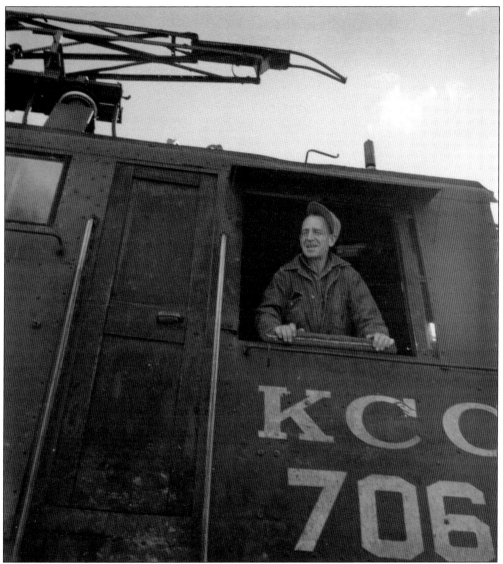

The electric locomotives of Utah Copper, and later Kennecott Copper Corporation's Utah Copper Division, used only a single engineer. During the 1950s, 1960s, and 1970s, as each shift ended, the locomotives were brought down to the 6190 yard, where crews were exchanged. Kennecott 706 was delivered in 1928 as one of the first electric locomotives at the Bingham copper mine.

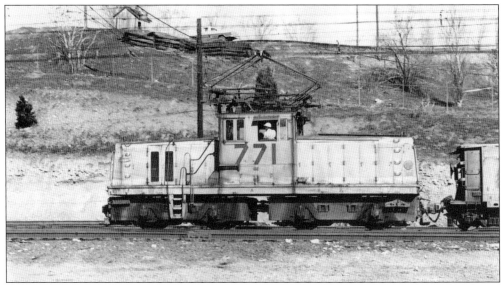

Kennecott Copper locomotive no. 771 was delivered in November 1955 as no. 871. It was one of eight 125-ton locomotives delivered as part of a large mine expansion that included the 5490 Tunnel. No. 771 was retired in November 1983 and is preserved at the Western Railway Museum in Rio Vista Junction, California.

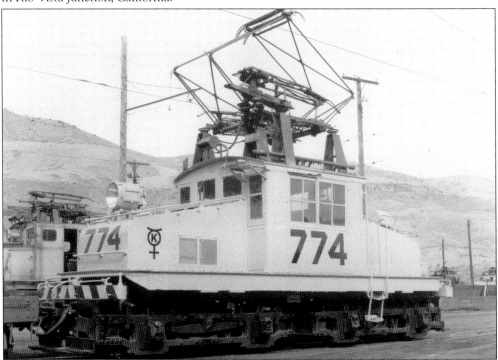

Kennecott Copper no. 774 was Utah Copper's first electric locomotive. Built in 1917 as Manufacturer's Railway no. 8, it was purchased secondhand by Utah Copper in 1924 when the car-dumper yards at the mills were electrified. Originally numbered as Utah Copper no. 1000, it was renumbered to Kennecott no. 1098 in 1964, then as Kennecott no. 798 in 1965, and renumbered again to Kennecott no. 774 in 1966.

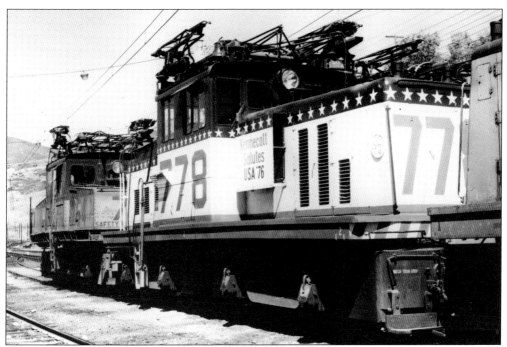

Several locomotives across the nation were repainted red, white, and blue in 1975 to commemorate the nation's 200th anniversary. Among them was Kennecott no. 778, which itself had come to Utah secondhand from Kennecott's operations at Chino, New Mexico. Built as Kennecott-Chino no. 4 in 1958, it was transferred to Utah in late 1971, where it was renumbered as no. 778. It was retired in November 1983.

As with any railroad operation, snow could at times hinder the normal operations of steam-powered trains on the Bingham and Garfield Railway and, later, the electrified Copperton Line. When snow became deep enough that regular operations were not keeping the line cleared, several special runs of a special snowplow train were made. When not needed, snowplows were stored at each end of the line at Magna and at Bingham.

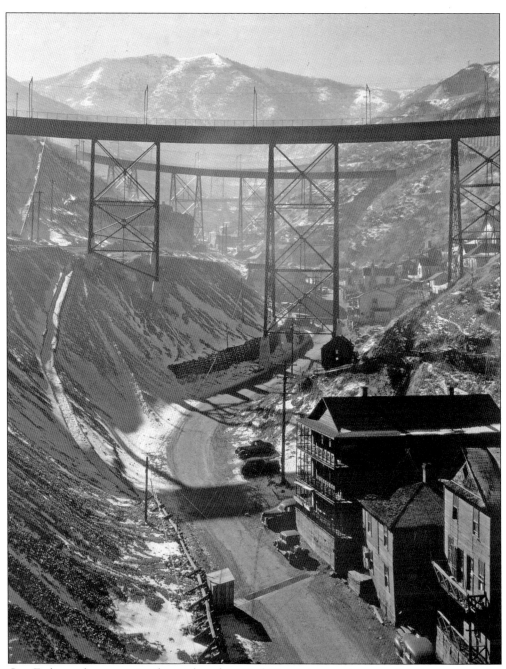

Carr Fork soon became a significant obstacle as Utah Copper's operations continued to expand after the 1910 merger with Boston Consolidated. The main Carr Fork Bridge was completed in 1911 as part of the Bingham and Garfield Railway. Surface rights were purchased on the northern slopes of Carr Fork (right), and several bridges were built to gain access to the new dumping grounds.

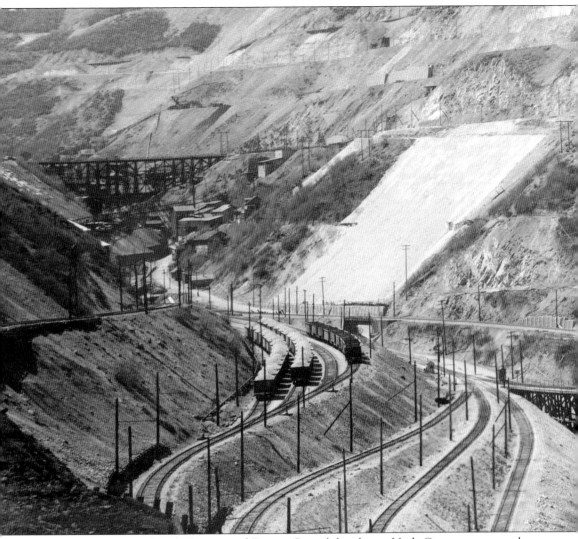

The merger in 1910 of Utah Copper and Boston Consolidated gave Utah Copper access to the Boston Con spurs in Carr Fork. In 1906, Utah-Apex Mining Company completed its aerial tramway, with ore bins at its lower terminal. Apex Yard was completed to serve these Utah-Apex ore bins. This undated photograph shows Apex Yard, as well as some of the network of tracks that later seemed to fill Carr Fork.

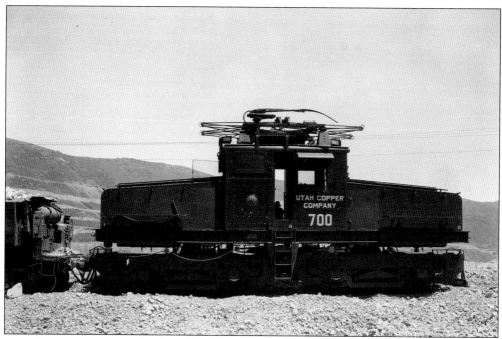

Utah Copper no. 700 was the first electric locomotive to be assigned to Utah Copper's Bingham Canyon mine. Delivered in May 1927, it took part in the motive power tests to determine the type of locomotives that would best be used to modernize railroad operations in the mine. The tests included steam 0-8-0 no. 500, a box-cab oil-electric numbered as 600, and the all-electric locomotive no. 700.

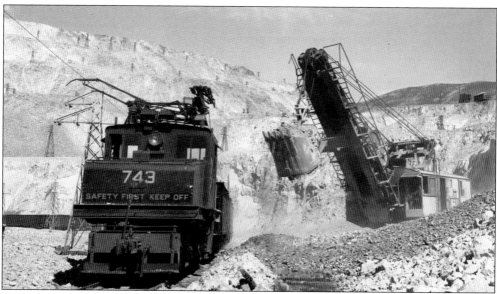

By the late 1930s, the open-pit mine had been fully electrified for 10 years. As operations continued to expand, an additional 19 locomotives were delivered in 1937, numbered as 742 to 760. Locomotive 743 was delivered in February 1937 as one of the first and is shown in this September 1939 photograph being loaded by shovel no. 25, an electric Marion model 4161 that was delivered in 1937.

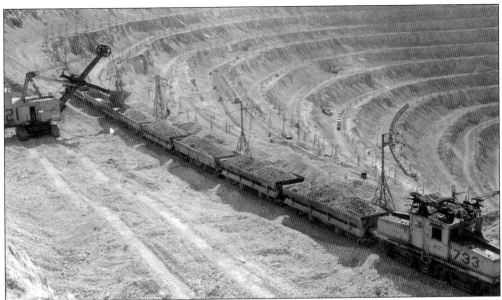

In the open-pit Bingham mine, the removal of waste rock was a major part of mining operations, as well as a major part of the company's operating expenses. To reduce excess costs, Utah Copper began using large side-dump cars and electric shovels. Shovel no. 21 was a Bucyrus model 190-B with an eight-cubic-yard bucket. The shovel was delivered to Kennecott's Bingham mine in November 1955.

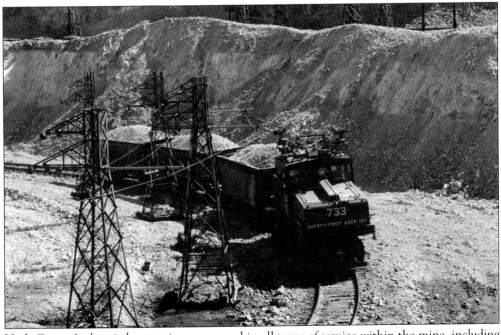

Utah Copper's electric locomotives were used in all types of service within the mine, including waste-train service, ore-train service, and maintenance-of-way service. This photograph, taken in the late 1940s, shows locomotive no. 733 moving a few loaded ore cars at the bottom of the open-pit mine. No. 733 was delivered in July 1929 among the second group of electric locomotives delivered to Utah Copper.

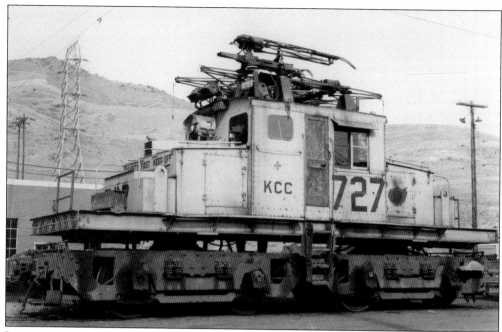

Locomotive no. 727 was the subject of several tests by the mechanical forces at Kennecott's Dry Fork shops. It was the only electric locomotive to receive shortened hoods for an as-yet-undocumented modification. Like all of the mine locomotives, no. 727 is shown in this November 1965 photograph fully equipped with side pantographs.

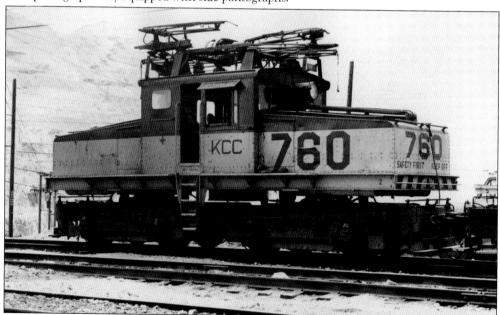

Kennecott no. 760 was delivered in October 1937, the last electric locomotive delivered in the original design configuration used by the very first electric locomotives in 1927–1928. The single-drop equalizer and coil springs used on the truck assemblies, connecting the axles and journal boxes, indicates that the locomotive had been modernized. The original design used a combination of leaf springs and single-axle equalizers (compare with photographs of no. 700).

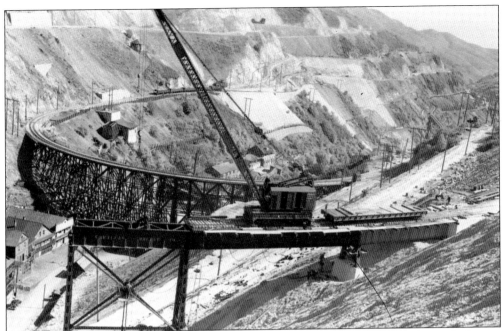

Continued expansion of the mine meant that dumping sites were needed for disposal of waste rock. Surface dumping rights were acquired along the north slopes of Carr Fork and along the lower parts of Bingham Canyon. To reach these dumping grounds, several bridges were constructed across Carr Fork, including bridges for the G Line and the H Line. The H Line Bridge is shown under construction in this undated photograph.

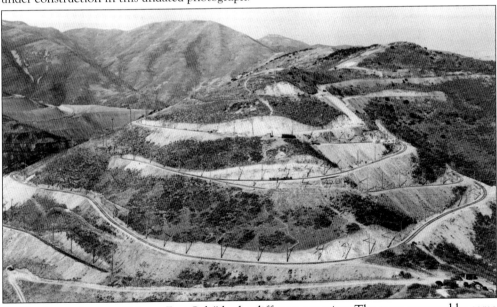

At Bingham, the term "Upper East Side" had a different meaning. The term was used by some employees to describe the mountaintop and ridge that separated Bingham Canyon from Salt Lake Valley to the east. In this undated photograph, looking north, the mountaintop is seen as it appeared during the 1930s after several switchback dump lines had been built to access waste-rock dumping grounds on the mountain's east slopes.

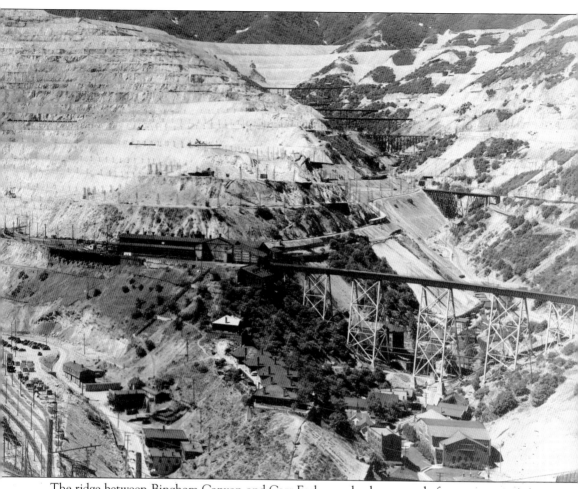

The ridge between Bingham Canyon and Carr Fork was slowly removed after open-cut mining started in 1906. By the 1930s, most of the mountain was gone, but a large part of the ridge remained. The ridge was the home to Utah Copper's railroad shops, as well as being the anchor point for the large Carr Fork Bridge, completed in 1911 and removed in 1958.

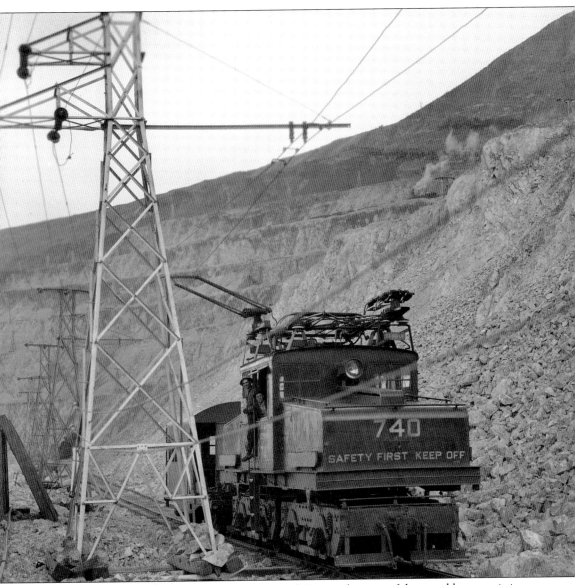

Electric railroading in the Bingham mine was successful in part because of the portable transmission towers used by Utah Copper (and Kennecott after the 1941 corporate name-change). The towers were movable and were not anchored. On the outside (left), they carried transmission lines from electrical substations, and on the opposite side (right), they carried the overhead catenary wire used by the electric locomotives.

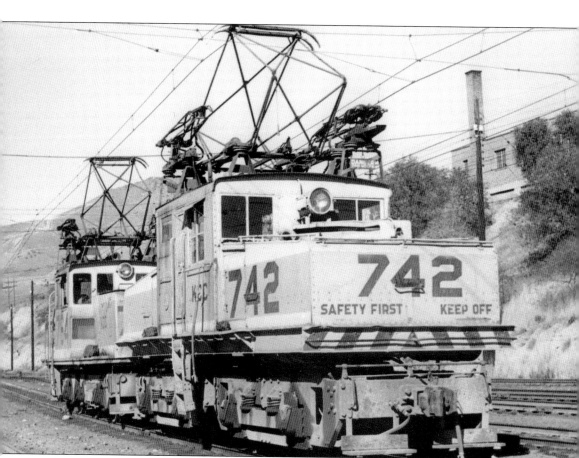

When delivered new from 1927 to 1937, Utah Copper's electric locomotives were painted completely black. Between the late 1950s and the mid-1960s, Kennecott applied three paint schemes to its electric mine locomotives. First was an all-yellow scheme, then yellow with a light-green band and the locomotive number in black, as shown here. The final scheme was yellow with the upper areas painted black.

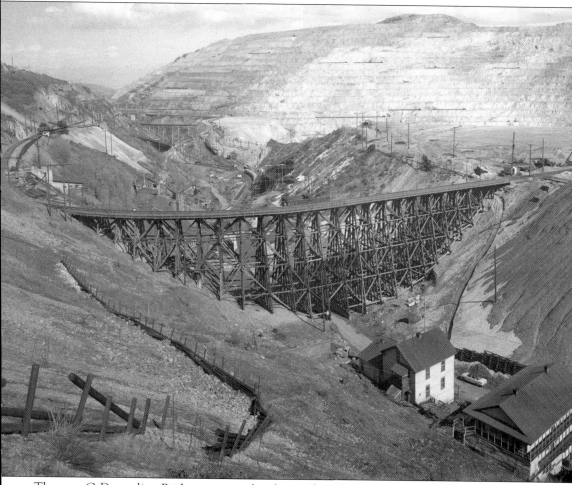

The new G Dump-line Bridge was completed in early 1954. It connected on the north (left) to the existing G Line. The ridge between Carr Fork and Main Canyon was continually being reduced, and the new bridge was a needed to accommodate changes in the G Line on the south (right) side of Carr Fork.

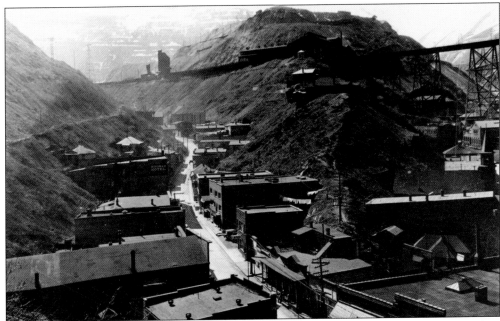

Bingham, Utah, became known as the town that was one street wide and seven miles long. Taken in March 1934, this photograph shows the junction where Carr Fork split off from Main Canyon. At the lower right is the Bingham Mercantile building, which sat at the highway intersection between the two canyons. The town's main street continued up the canyon for another two miles, ending at Copperfield in Upper Bingham Canyon.

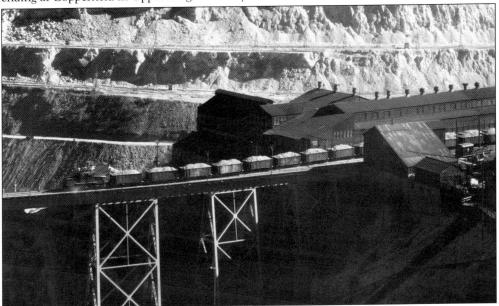

The Utah Copper maintenance shops on the ridge between Carr Fork and Main Canyon were the focus of railroad-maintenance activities at the mine. The Bingham shops were where steam locomotives were repaired, as well as electric locomotives, ore cars, and waste cars. They remained in place until mid-1958, but most of their function was transferred in mid-1949 when Dry Fork shops were completed further down the canyon.

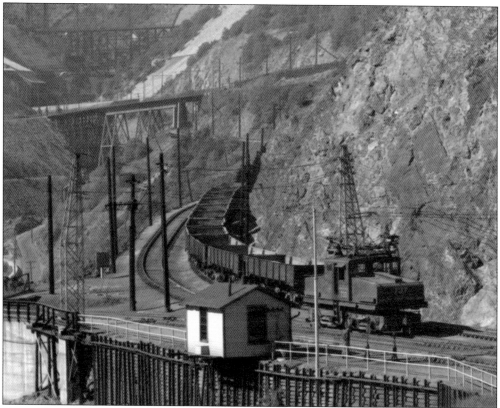

Owned by Utah Copper Company, the Bingham and Garfield was a common carrier and served several mines in Bingham Canyon, although by 1942 there were just 10 of these mines remaining. B&G accessed other mines' ore bins over Utah Copper's electrified tracks, using locomotives assigned to B&G. No. 737 is shown here as it moves past several empty cars bound for the Utah-Apex Mine in Carr Fork.

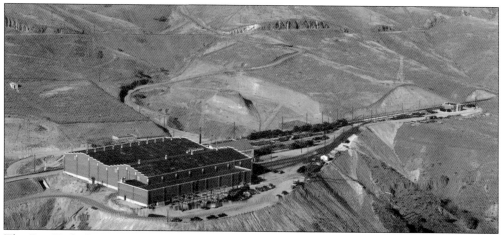

The Dry Fork shops were completed in mid-1949 and located adjacent to the new C-C Line, completed in 1946. The location at Dry Fork Gulch was the previous site of the original Utah Copper Copperton Mill, completed in 1903 and dismantled in 1910, where Utah Copper developed its original methods for the extraction of copper from low-grade ore.

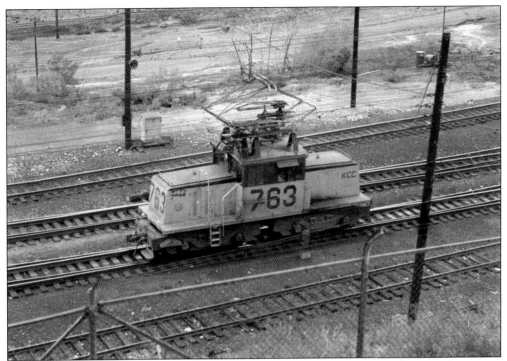

Copperton Yard was the assembly yard for loaded ore cars bound for the mills, as well as empty ore cars bound for the mine. This October 1977 photograph shows Kennecott no. 763, a 90-ton locomotive built in 1942. Having dropped its train of loads, no. 763 moves through Copperton Yard to tie onto a train made up of empty ore cars.

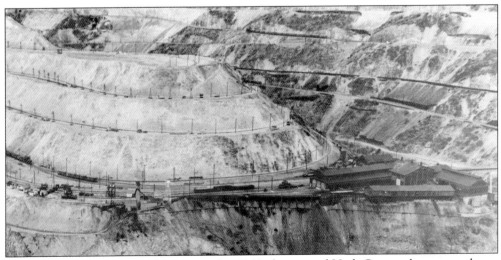

By the date of this photograph in November 1944, the original Utah Copper shops were almost isolated by the continued growth of the open-pit mine. The ridge between Main Canyon and Carr Fork had almost disappeared, with the mine tracks having been shifted considerably from their previous locations. The shops and adjacent Carr Fork Bridge were the last remaining parts of the original A-level yard.

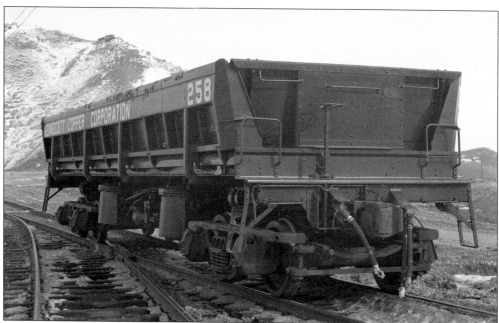

Kennecott Copper air-dump car no. 258 was part of an order of 50 cars delivered in November 1949. These cars were used to move and dump waste rock at the Bingham mine, and held 50 tons, using large air cylinders to tip the car body to one side or the other. Built by Magor Car Corporation, these 50 were followed two years later by an additional 40 cars.

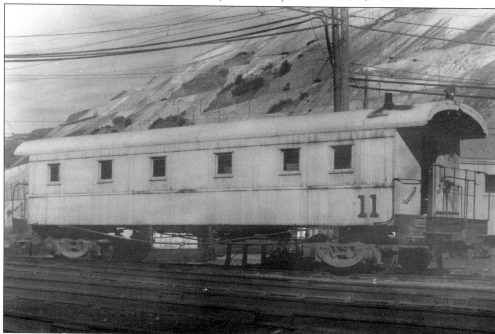

Kennecott used secondhand coaches from other railroads to transport shovel crews, train crews, and track-maintenance crews within the mine as they started and ended their shifts. Coach no. 11 is shown here in June 1966; it was purchased in 1947 from the bankrupt Salt Lake and Utah Railroad. It had been modified from its days as SL&U no. 701 but retained its original trucks.

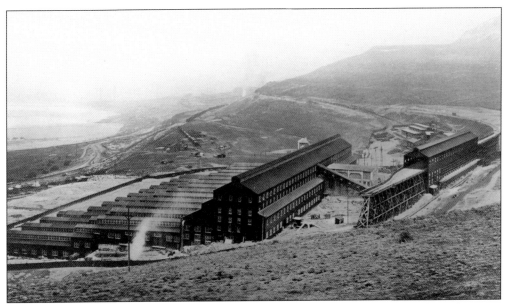

The Utah Copper mill at Arthur was completed in January 1908 by Boston Consolidated Mining Company. In 1906, both Boston Con and Utah Copper began mining what became known as Bingham Canyon's "Copper Mountain," with Boston Con working the upper levels and Utah Copper working the lower levels. In 1910, the two companies merged, giving Utah Copper unimpeded development of the entire mountain.

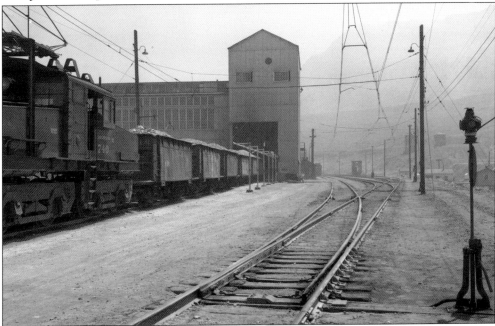

Utah Copper no. 740 was one of four "85-ton" locomotives assigned to mill dumper service. Together with Utah Copper no. 600, all five locomotives were transferred to the Bingham mine in December 1948 with the startup of the new, electrified Copperton Line. The dumper yards at the mills were converted to 3,000 VDC to allow use of the larger Copperton Line locomotives in rotation with regular mine-to-mill service.

# Five

# MILL OPERATIONS

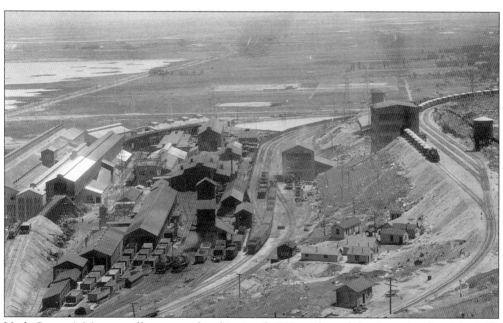

Utah Copper's Magna mill was completed in April 1907, with work having started in July 1905. This photograph from 1924 shows the newly completed car dumper (at right) with its similarly new switching yard, known as Fogarty Yard, just prior to the yard's electrification. After it had been electrified, the dumper yard used one of the two small electric locomotives purchased secondhand for the purpose.

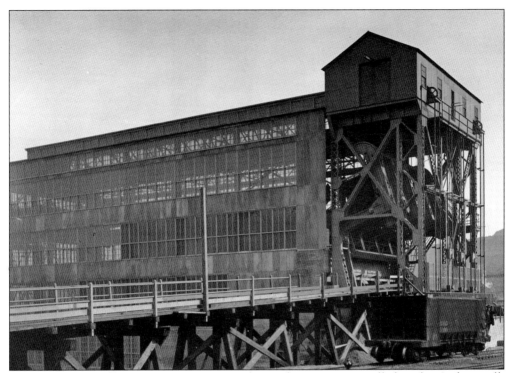

In 1918, a new Wellman-Seaver-Morgan single-car dumper was installed at the Arthur mill. The new car dumper replaced the mill's original 10,000-ton steel-ore bin, which had been fed by bottom-dumping ore cars. Loaded ore cars were moved using steam locomotives to the new dumper from an adjacent switching yard, also new. Individual ore cars were moved up the incline to the car dumper with a car pusher. After being dumped, the empty cars were allowed to roll by gravity out of the dumper to a kickback track that reversed the car's direction. The empty car continued through a safety switch and coasted into a gathering yard. The new dumper yard used steam locomotives from 1918 until it was electrified in 1924.

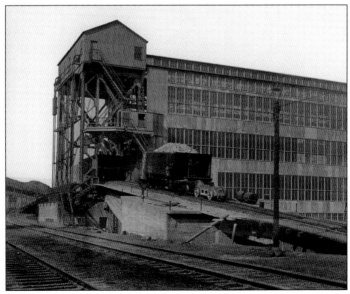

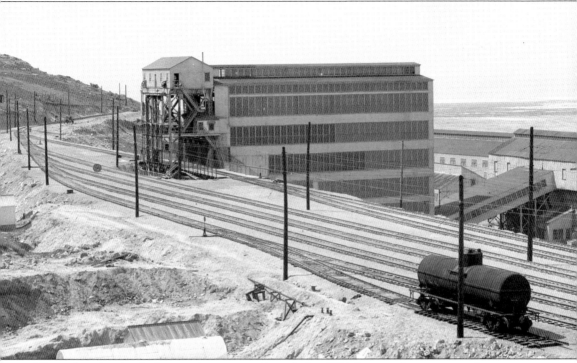

The rail yard at the Arthur car dumper was electrified in 1924. Prior to the conversion from steam locomotives to electric locomotives, the ground level of the yard itself was raised to put all of the tracks at the same level as the car dumper. This would do away with the "mule" (car pusher) and allow direct access to switch the cars in and out of the dumper.

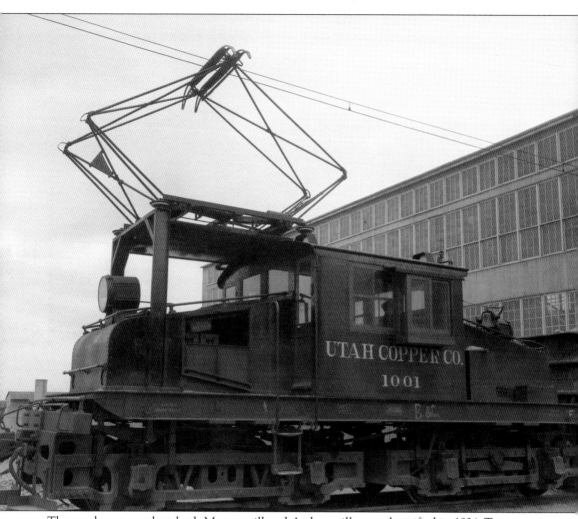

The car-dumper yards at both Magna mill and Arthur mill were electrified in 1924. To serve as motive power, two electric locomotives were purchased secondhand from Manufacturers Railway in St. Louis, Missouri. This photograph, taken in April 1941, shows Utah Copper no. 1001 in service at the Arthur mill.

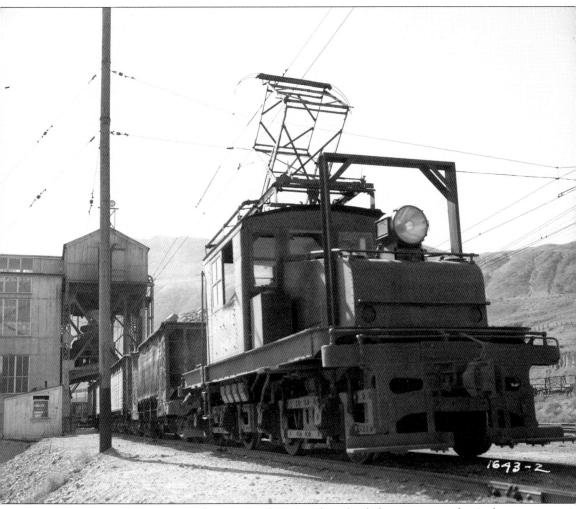

Utah Copper no. 1001 is shown here in April 1941 pushing loaded ore cars into the Arthur car dumper. The Arthur mill was the first of the two mills to receive a car dumper, which used a "mule" to move uncoupled single cars into the dumper. The handling of ore cars was greatly improved after conversion to using an electric locomotive to move cars into and out of the dumper.

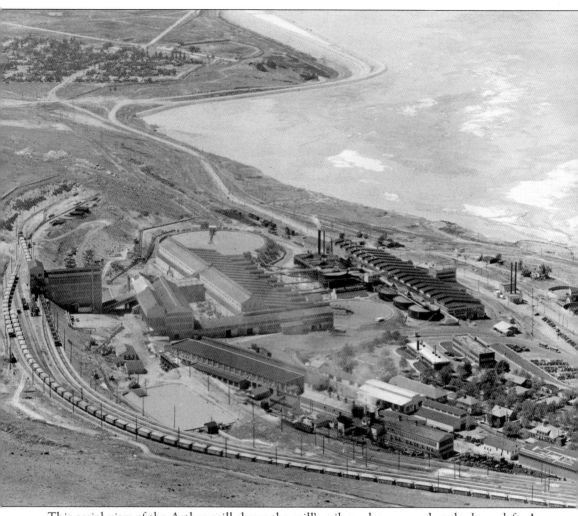

This aerial view of the Arthur mill shows the mill's rail-car dumper yard at the lower left. As trains of 80 to 85 loaded ore cars arrived from the mine, they were separated into smaller trains of 13 cars each. These smaller trains were then moved to the far side of the dumper. The loaded cars were then dumped, one car at a time.

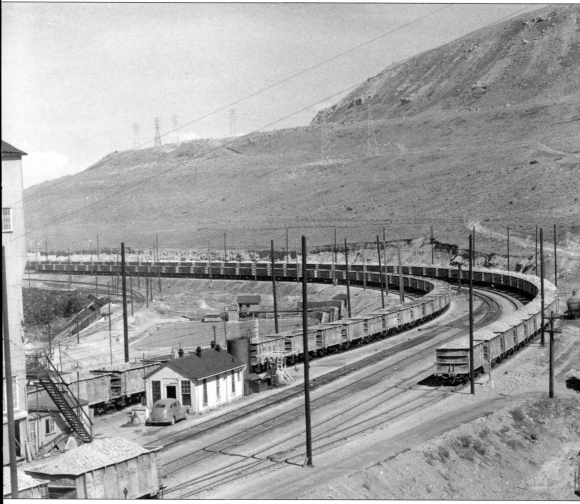

The dumper yard at the Arthur mill held both loaded cars from the mine and empty cars waiting to return to the mine to be reloaded. On the left is a string of empty cars that have been dumped. On the right is an entire train of loaded cars. The track immediately to the right of the small building was used to store bad order cars needing repairs.

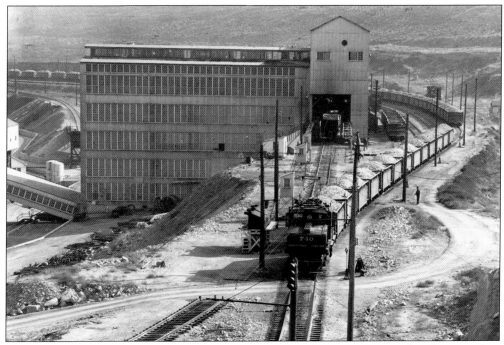

Electric locomotive no. 740 was one of four locomotives (737, 738, 740, and 741) assigned to the Ore Delivery Department, and it was used at the Arthur and Magna dumper yards and in the mine for common-carrier service. Nos. 737, 738, 740, and 741 each weighed 93 tons, with 55,600 pounds tractive effort, and were only used at the dumpers whenever one of the two 80-ton ex-Manufacturer's Railway locomotives was out of service.

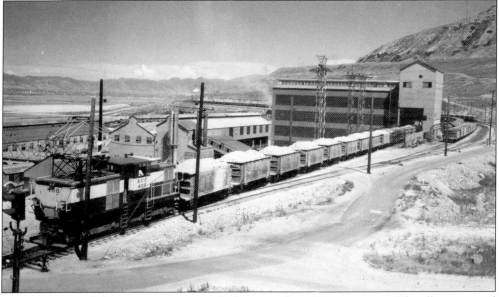

From 1924 onward, dumping operations at Arthur were done 13 cars at a time. The all-time record for the number of cars dumped in one day at Arthur was set in 1943 when 633 were dumped in a single 24-hour period. This 1965 photograph shows the recently received no. 408 serving as the Arthur dump engine.

The Fogarty dumper yard is full in this undated photograph. The locomotive shown is one of the original Copperton Line locomotives, indicating that the photograph was taken between 1948 and 1964. Until the mid-1960s, two of the seven road engines were assigned as dumper engines at Fogarty and Arthur, while two sets of two worked the road trains, and a spare remained at the shop.

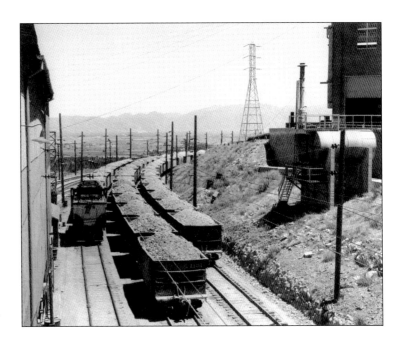

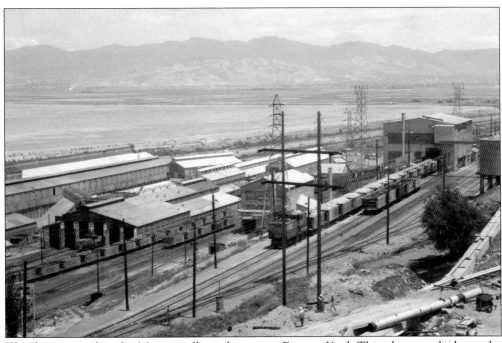

The dumper yard at the Magna mill was known as Fogarty Yard. This photograph shows the adjacent locomotive shops, which were built to service the steam locomotives of Bingham and Garfield Railway. With the conversion to electric railroading in 1948, the shops simply began working on the electric locomotives of the Copperton Line. Retired steam locomotives remained stored nearby for another 10 years.

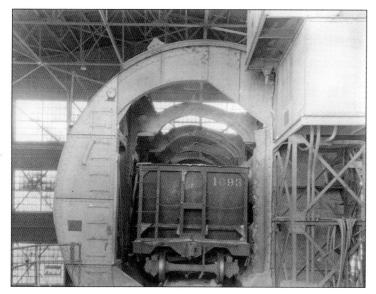

This 1924 photograph shows one of the older-design ore cars being dumped. In the early 1960s, Kennecott began building its own cars at its Magna car shops. The car dumper at Fogarty remained in place until the crushing portion of the Magna mill was closed in 1988, while the mill remained in operation until late 2001 as part of the North Concentrator Complex.

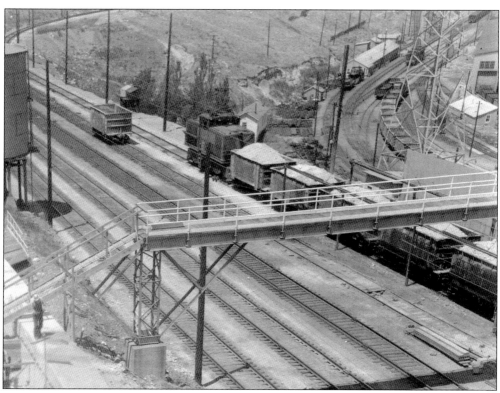

Fogarty Yard served the Magna car dumper, and it was located on the hill between the power plant and the mill. The Magna switching yard (upper right) was located slightly lower on the hill and was where Kennecott interchanged freight cars with D&RGW. This latter common-carrier railroad technically owned one of the through tracks in Magna Yard, giving D&RGW access to the Arthur mill and the Garfield Smelter.

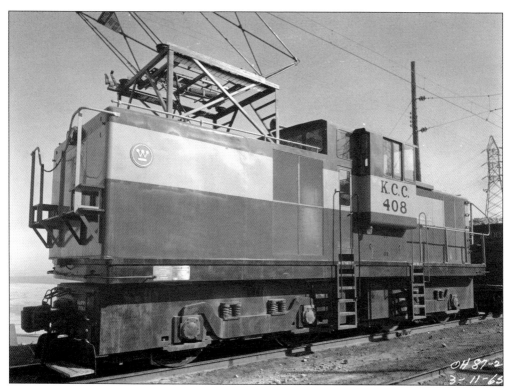

Kennecott Copper Corporation no. 408 was a direct result of the mid-1960s expansion of the company's output. Changes to increase production were made in every part of the mining and production of copper. Increased production at the mine included trucks for waste removal, along with additional ore cars to move the copper ore from mine to mill. The Bonneville mill was completed as a third mill, which in turn meant more trains needed to be moved between mine and mill. Assigning the two dumper engines to road service required that more locomotives were needed as dumper engines. These additional locomotives came from Kennecott's operations in Chino, New Mexico. No. 408 was rebuilt from Chino no. 2, including an extended-width operating cab to give the engineer clear visibility of crew members at each car dumper.

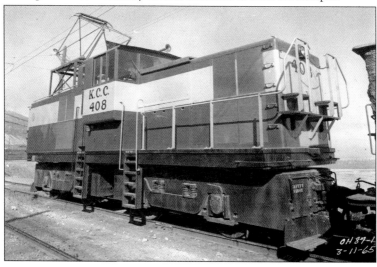

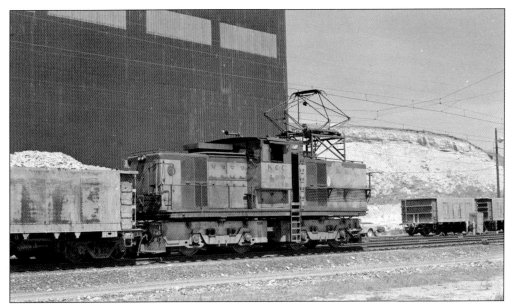

The Bonneville crusher went into service in September 1966, and by 1972 it was receiving 300 loaded ore cars per day. Kennecott dumper engine no. 409, shown here at Bonneville, was rebuilt from Chino no. 3 and entered service in Utah in early 1965. No. 409 was retired in November 1985 and is preserved at the Boone Valley Historical Society in Boone, Iowa.

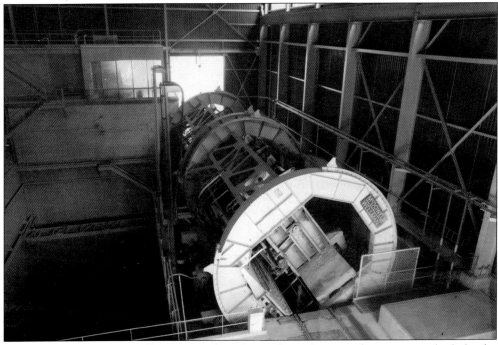

The car dumper at Bonneville was a modern design, housed in a modern structure built for the purpose. It dumped two cars at a time. The Bonneville crushing and grinding mill sent its ore to the Magna flotation mill by way of a water slurry pipeline. Bonneville remained open and continued to grind ore for the Magna flotation mill until the entire North Concentrator Complex was closed in late 2001.

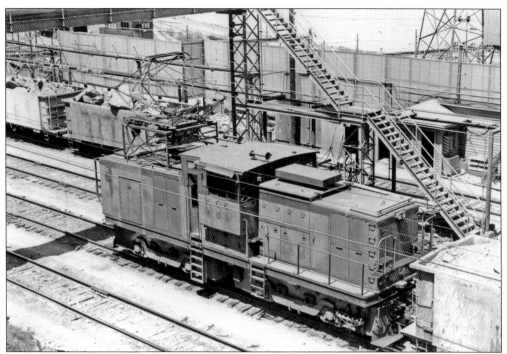

The three rebuilt Chino locomotives were assigned to all three car dumpers: Magna, Arthur, and Bonneville. No. 408 is shown here in March 1972 working at Magna. Note the ore cars in the background carrying extra-large boulders. These cars were dumped at the end of each shift, because the large boulders required extra time to break them into small enough pieces to fit into the primary crusher.

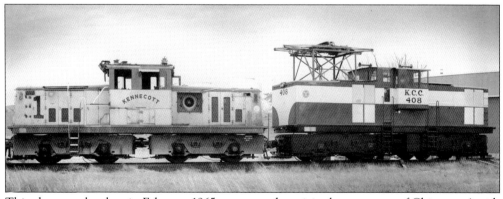

This photograph taken in February 1965 compares the original appearance of Chino no. 1 with what would be its later appearance as seen on Kennecott no. 408. The three Chino locomotives were converted from the 750 volts DC used in New Mexico to the 3,000 volts DC used by Kennecott at its ore-haulage plant in Utah. The conversion included larger body components, as well as extended-visibility cabs.

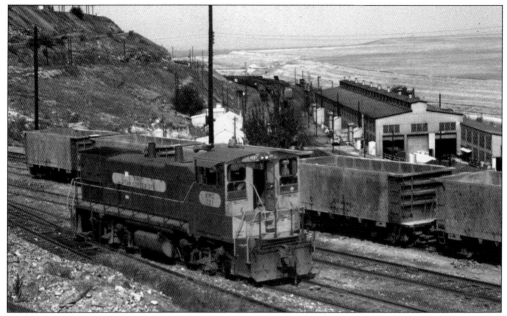

The car-dumper engines were changed to diesel-electric in January 1979, at which time the overhead catenary throughout the dumper yards was removed. This photograph from September 1983 shows Kennecott no. 121 in service at Fogarty. In the background (upper right) are Magna Yard and the Magna car shops, which continued to repair ore cars and construct replacement cars at the rate of a new car each week.

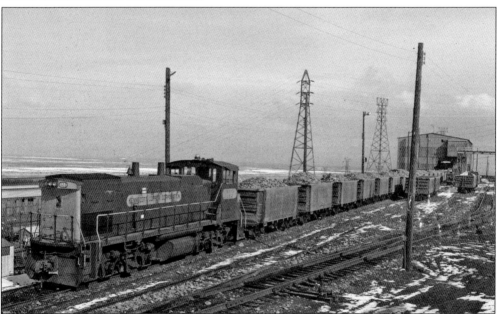

The Magna car dumper, along with the adjacent Fogarty Yard, was put into service in April 1907 when the first train of loaded ore cars arrived from the Bingham mine via the Rio Grande Western Railway. The yard remained in service until the North Concentrator Complex was shut down in late 2001. Kennecott no. 122 was delivered in 1978 and retired in 1997. It later became Union Pacific no. 1429.

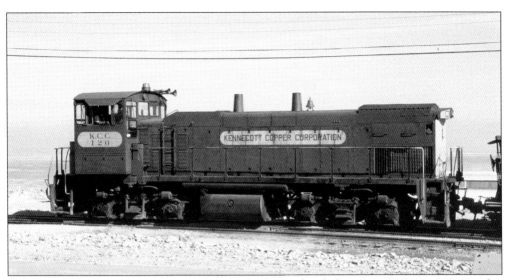

The car-dumper engines were changed from electric to diesel-electric in January 1979 just after the Ore Haulage mainline was converted. Kennecott selected the MP15AC, a standard model made by General Motors' Electro-Motive Division. Kennecott no. 120 was built in December 1978 and entered service in January 8, 1979. It was retired and sold in October 2003 and is now in service as Canadian Pacific no. 1446.

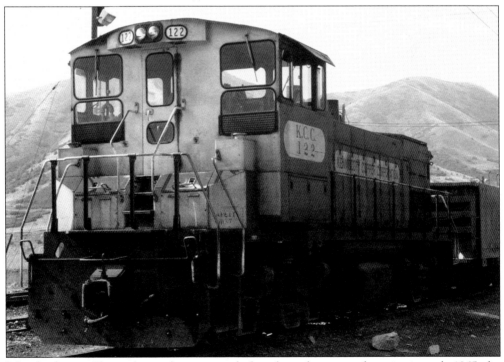

Like the former Chino electric locomotives before them that entered service in early 1965, the replacement diesel locomotives assigned to dumper service also had their cabs extended. The three MP15ACs were built new in December 1978 with their cabs extended 13 inches on the engineer's side for improved visibility. When retired and sold in 1997 and 2003, respectively, the locomotives had their cab extensions removed by their new owners.

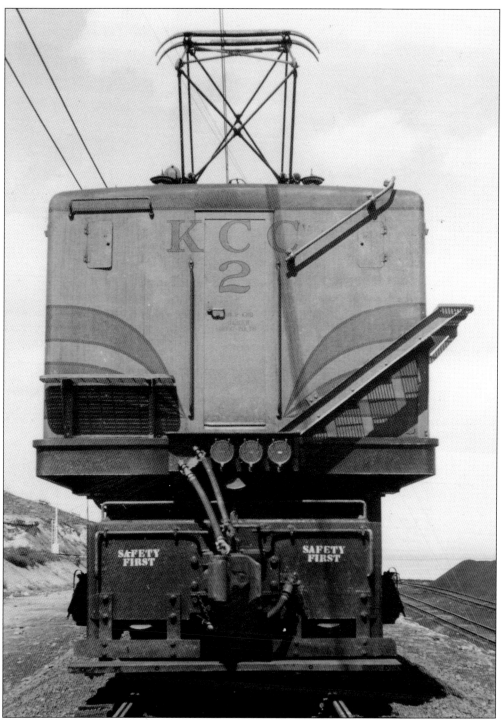

This is the face of Kennecott's no. 2, assigned solely to the company's Ore Haulage Division. Delivered new in November 1947, no. 2 was one of a total of seven electric locomotives used on the new Copperton Line to bring entire trains of copper ore down from the Bingham mine to Kennecott's two mills, 16 miles north on the south shore of Great Salt Lake.

# *Six*
# ORE HAULAGE

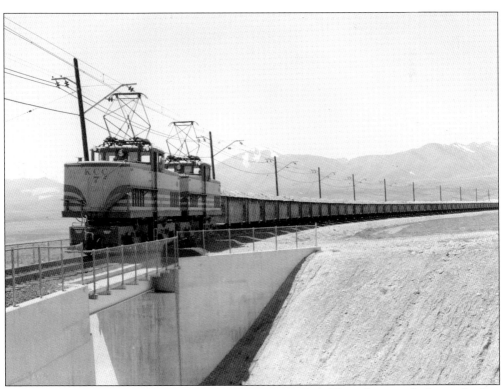

The new Copperton Line began operations on May 2, 1948. This photograph shows the first loaded train as it crossed the highway between Bingham and Magna. Each of the two locomotives was rated at 3,200 horsepower, giving the paired set a rating of 6,400 horsepower. Each train was made up of an average of 70 cars of copper ore. The capacity was reported to be 30 million tons per year.

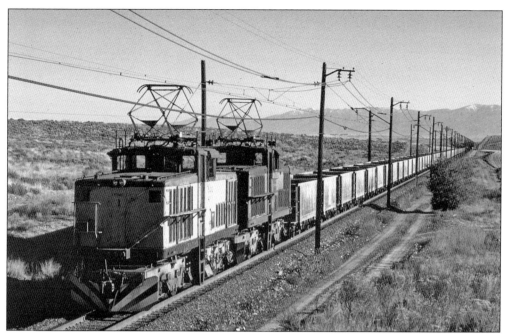

This photograph is dated September 23, 1978, very near the end of electrified operations. The train of empty ore cars is being moved back to the Bingham mine to be reloaded. The typical train of empties was made up of an average of 80 cars, with the prevailing grade being against empties as they returned to the mine.

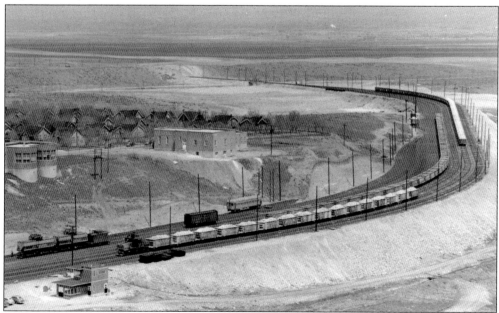

As seen in this May 1948 photograph, Copperton Yard was very sparse and minimal in its layout. Over the years, many tracks were added to accommodate continued traffic growth from expanding mine operations. The building at the lower left was the operations and maintenance headquarters for the new Copperton Line, and its upper floor held the dispatching desk for the entire line between the mine and the mills.

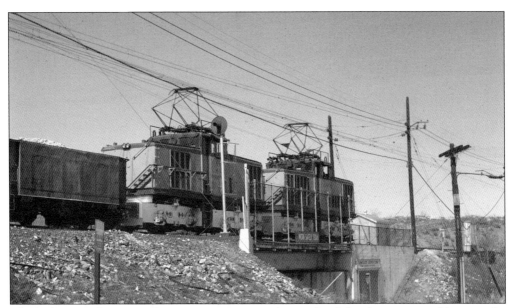

The highway underpass at Copperton remains in place today. It has been a central location for Copperton Line operations since the first days in May 1948. The overhead catenary wires at the bridge were energized with the 3,000 volts DC of the mainline and the 750 volts DC of the mine railroad. The mainline locomotives switched from one system to the other as trains passed over the bridge.

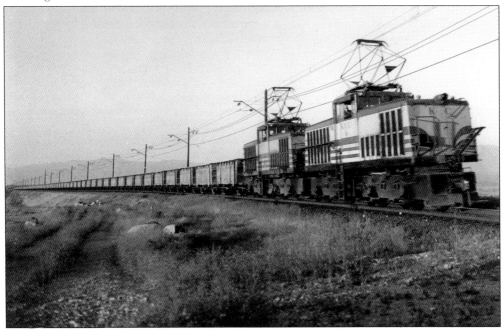

From the initial operations in 1948 through the expansion of the mid-1960s, a workday at the Ore Haulage Division consisted of five separate shifts. The first crew started at 2:00 a.m., followed by another at 5:45 a.m., with later crews starting at 10:45 a.m., 4:00 p.m., and 9:00 p.m. Each crew usually made three round trips between Copperton Yard and either the Magna mill or Arthur mill.

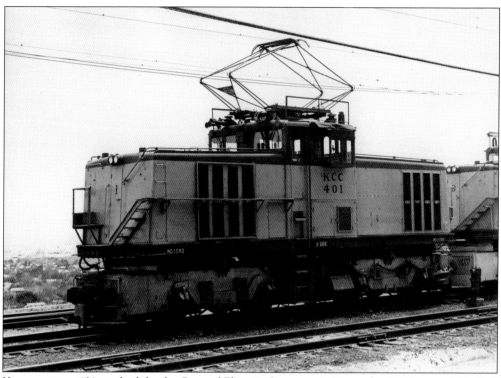

Kennecott no. 401 was built by the General Electric Company in November 1947 as no. 1. Each of the seven locomotives was rated at 3,200 horsepower and came equipped with dynamic braking, as indicated by the series of vents on the locomotive sides. Dynamic braking used the force of gravity to turn the locomotive's electric motors into generators, with the excess electricity being fed into resistors and dissipated as heat.

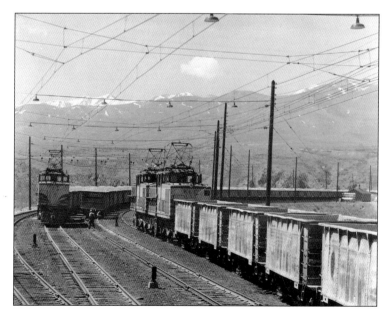

Copperton Yard was at times very busy, as trains of empty ore cars were returned to the mine, and full trains of loads waited their turn to be moved to the mills. In this undated photograph, no. 5 and its train of empties enters Copperton Yard, passing two fully loaded trains on adjacent tracks. Kennecott no. 7 stands ready to start moving as soon as the empties clear the mainline.

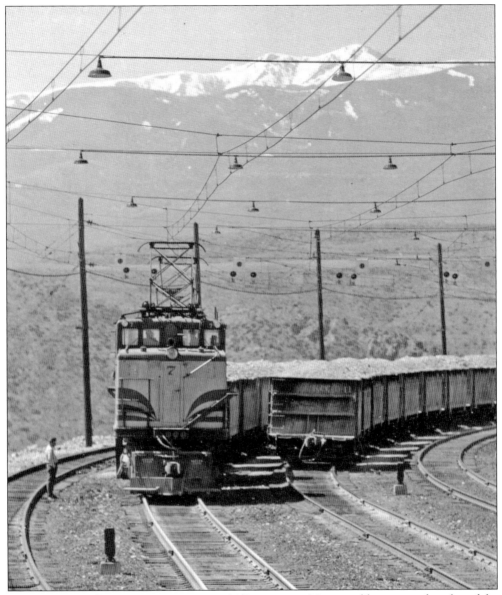
Kennecott's Bingham Canyon mine was a 24/7 operation. Mining seldom stopped or slowed for the night or due to bad weather. Copperton Yard had a full complement of overhead lighting to ensure safe work zones. Locomotive no. 7 stands waiting for clearance to take its loaded ore train to one of the mills. The locomotives' single-digit numbers were changed to their later 400-series numbers in May 1964.

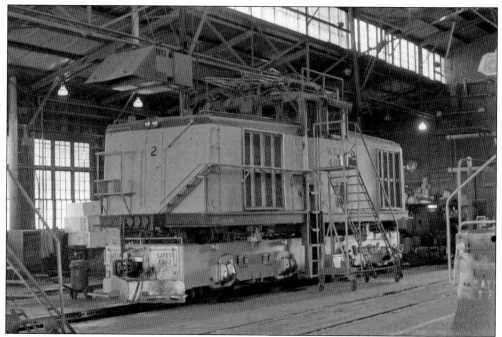

Kennecott's repair crews at its Magna locomotive shop were capable of performing whatever was needed to keep the fleet of electric locomotives in top condition. The same shop facility also served the steam locomotives of the Bingham and Garfield Railway, and it simply changed from maintaining steam locomotives to maintaining electric locomotives in 1948; it changed again in 1978, when diesel locomotives arrived on the property.

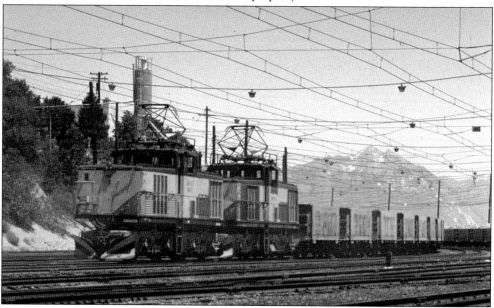

This photograph from June 1973 shows Kennecott no. 407 and no. 402 about to uncouple from their train of empty ore cars. The set of locomotives would then pull to the far-western end of Copperton Yard. Their crew was then guided via radio and signal lights back eastward to the opposite end, where the locomotives would be coupled to a waiting train of loaded ore cars.

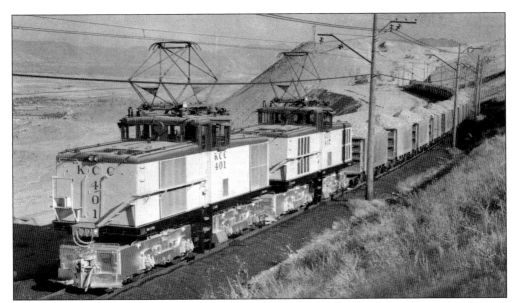

Kennecott Copperton Line electrics 401 and 407 lead a train of loaded ore cars into the new Bonneville mill yard in 1967. The mill and adjacent crusher started operations in September 1966. Operations continued until the Bonneville mill was closed as part of the North Concentrator Complex in late 2001.

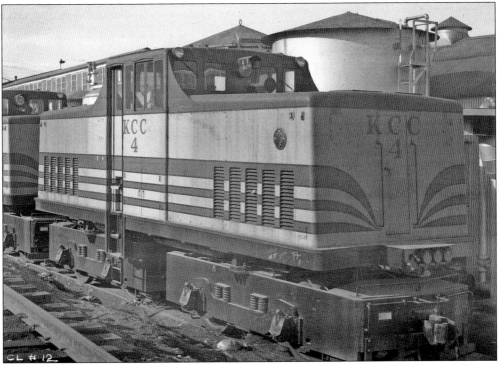

The seven large electric locomotives for the Copperton Line were completed by General Electric in November 1947. They arrived on Kennecott property within a few short weeks, where they were stored awaiting startup of operations of the new railroad. As delivered, the new locomotives had a small bit of sheet metal as a style element between the top of the hood and the cab wall.

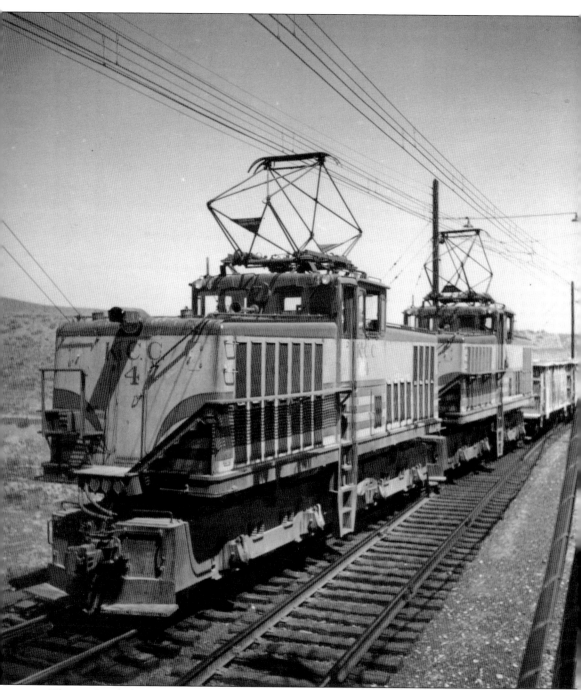

This undated photograph shows Kennecott no. 4 and a second Copperton Line locomotive with their train of empty ore cars passing a loaded train at the Copperton bridge. The maze of overhead wires shows the location where the 3,000 volts DC of the mainline met the 750 volts DC of the mine railroad. The mainline locomotives switched from the mainline system to the mine system at the bridge.

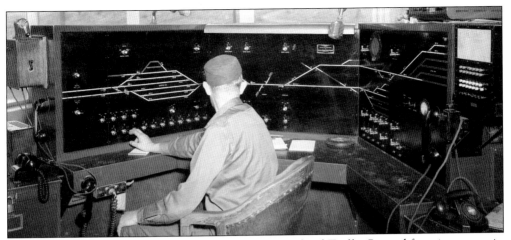

Control of the new Copperton Line made use of Centralized Traffic Control from its startup in 1948. The original board, shown here in March 1958, was a GRS model NX control board that showed Copperton Yard (left) and the two mill yards, Arthur (upper right), and Fogarty (lower right). With the addition of the Bonneville mill in the late 1960s, the Bonneville extension was added.

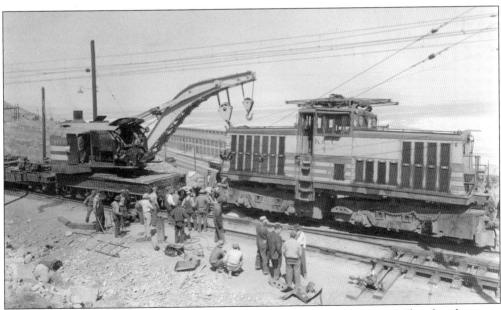

On Kennecott's mainline, as on any busy railroad, accidents did happen. This derailment in April 1954 was not serious, but it still put one of the large electric locomotives at risk of toppling over. This particular locomotive was assigned as the Magna dumper engine and derailed at the tail switch of Fogarty Yard.

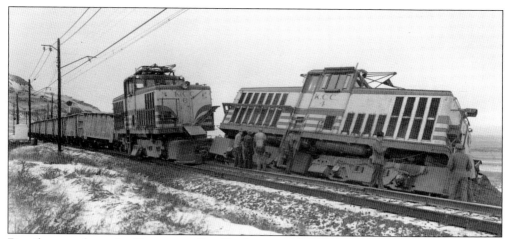

Derailments along the Copperton Ore Haulage mainline were rare. This accident in early December 1951 was caused by a broken axle on the leading locomotive, causing it to nose into the dirt of the embankment. Luckily, no one was injured, but both locomotives derailed, along with the leading empty ore car.

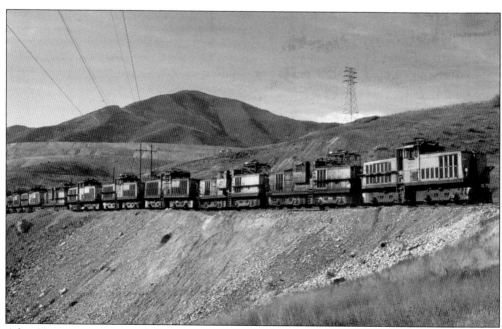

After Kennecott converted the motive power on the Ore Haulage mainline from electrics to diesels in mid-December 1978, all seven mainline electrics, as well as the three dumper engines, were transferred to the Bingham mine. All 10 locomotives remained in storage at Dry Fork shops until they were formally retired in March 1982. This photograph from November 1983 shows that the locomotives had not yet been scrapped.

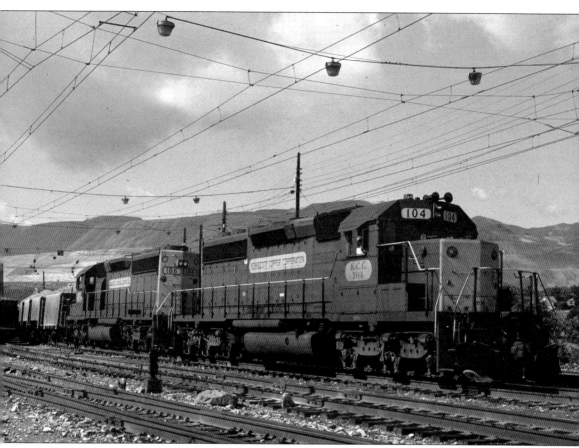

In late 1978, the seven large electric locomotives used on the Copperton Line since 1948 were replaced by seven model SD40-2 diesel-electric locomotives delivered new from General Motors' Electro-Motive Division. They were assigned in the same two-locomotive configuration as the all-electric locomotives they replaced. Due to declining copper prices and curtailed operations, all seven SD40-2s were removed from service just six years later.

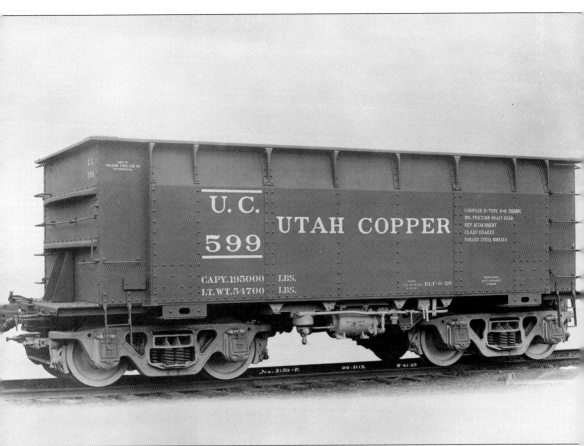

Utah Copper ore car no. 599 was delivered in mid-1929 and is shown here as an example of the appearance of hundreds of similar cars created by commercial car builders. The car had riveted construction with a capacity of a bit less than 100 tons. Even in those early years, the company had discovered the value of truck assemblies equipped with dual brake shoes for each wheel.

Kennecott Copper began manufacturing its own ore cars in February 1963, when the Magna car-shop crew began an assembly-line process that produced 10 complete car bodies per month. The process included all-new fabricated car bodies, as well as all-new under-frame assemblies. Air-brake equipment and truck assemblies were refurbished items.

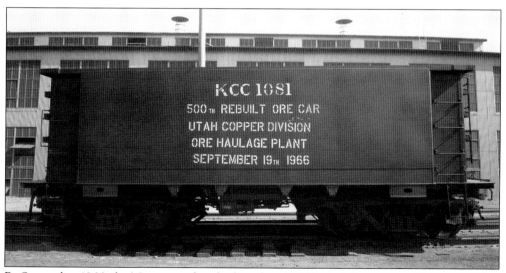

By September 1966, the Magna car shop had produced 500 "rebuilt" ore cars, which were in fact all-new ore car bodies equipped with minimal but sufficient rebuilt components to qualify for available tax credits. At first, the rebuilt ore cars were equipped with friction bearings on the wheel assemblies. In September 1965, the company began using roller bearings.

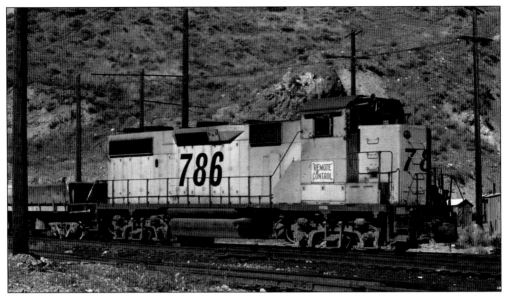

Kennecott no. 786, EMD model GP39-2, was delivered to the Bingham mine in February 1977, entering immediately into waste-train service. It was among the group of GP39-2s built with cabs that had been raised to improve visibility. These 28 special locomotives were also equipped with raised fuel tanks to keep the tanks safe while traveling among large and potentially damaging rocks within the mine.

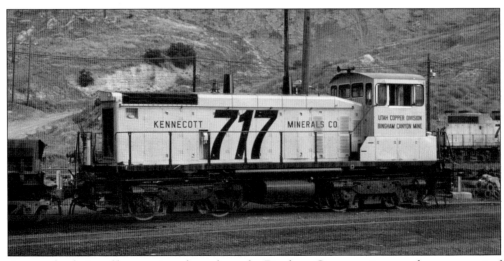

Among the duties of locomotives throughout the Bingham Canyon mine was the movement of tools, machines, and materials instead of loaded and empty ore cars. These movements did not need the higher horsepower of the GP39-2s. For that task, Kennecott leased four secondhand model SW1500 switching locomotives. Built for the Rock Island Railroad in 1966, they came to Kennecott in 1982 via Morrison Knudsen and were numbered as Kennecott 714–717.

# Seven

# Diesel Operations

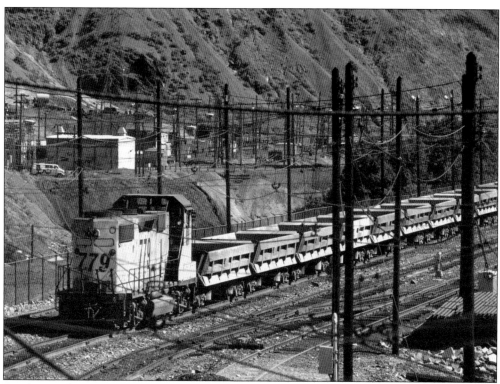

Bingham's electric locomotives served well from 1927 through the late 1970s. The first were sidetracked when trucks took over waste-haulage at the mine in the mid- and late 1960s. A group of leased UP, D&RGW, and AT&SF locomotives were successfully tested from 1973 to 1978 on the remaining waste trains, leading to the purchase of new GP39-2s in 1977. Kennecott no. 779 was the first, delivered in February 1977.

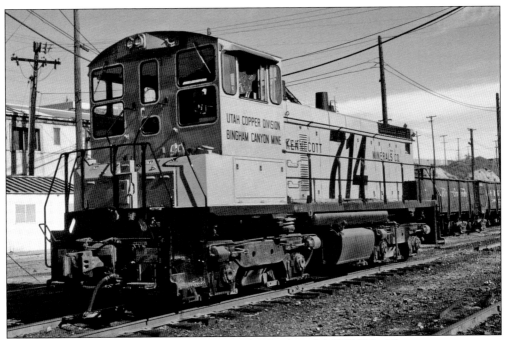

Kennecott no. 714 was one of four former Rock Island model SW1500s. Their assignment was light-duty switching throughout the mine. Built in 1966, all four became available when the operations of the Rock Island Railroad were shut down on March 31, 1980. The four locomotives remained in storage until they were leased to Kennecott in December 1982. Kennecott returned them to their owner in April 1998.

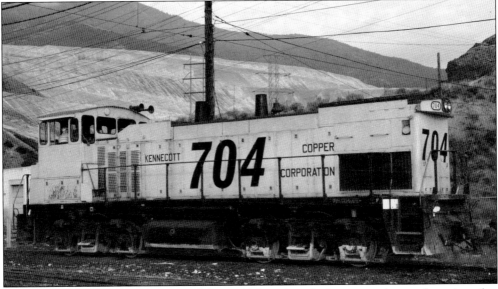

Kennecott no. 704 was an EMD model MP15AC and worked as a switcher at the mine after its delivery in late December 1978. It and its twin, no. 701, were identical to the three-dumper MP15ACs, except for the latter's extended-width cabs. In September 1983, no. 704 was transferred to ore haulage and changed from its original scheme shown here to the Ore Haulage Division's green and yellow colors.

Meant to be direct replacements to the electric mine locomotives, with windows on all four sides, the new GP39-2 diesel locomotives arrived from the EMD factory with cabs that were 26 inches higher than standard GP39-2s. The raised cabs included windows in their rear walls that allowed locomotive engineers to see over the top of each locomotive.

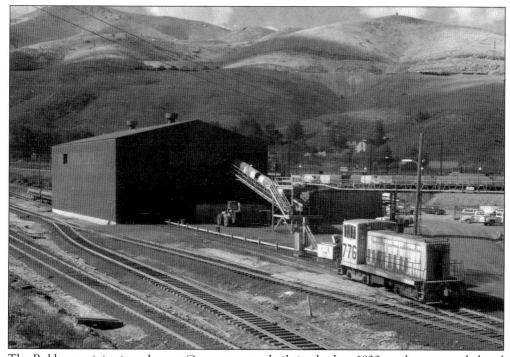

The Robbe precipitation plant at Copperton was built in the late 1920s and was upgraded and improved on a regular basis. In October 1958, Kennecott purchased the plant, and in February 1965 it was completely rebuilt and modernized. As part of that modernization, two small General Electric locomotives were transferred from Kennecott's Nevada operations to serve as in-plant switching locomotives to move railcars loaded with scrap steel.

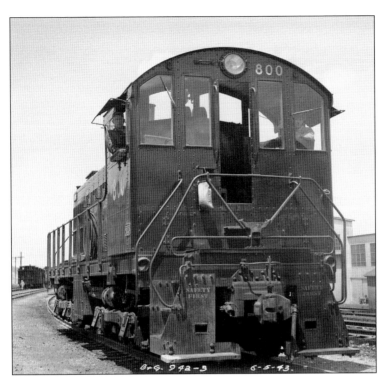

Bingham and Garfield no. 800 was an Alco model S-2, a 1,000-horsepower switching locomotive, and was the railroad's first diesel locomotive. It was built in July 1942. The locomotive was purchased at the same time as Utah Copper electric no. 600, apparently to test the possibility of dieselizing the car-dumper yards at Magna and Arthur. The diesel was declared surplus and was transferred to Kennecott's Nevada operation in 1944.

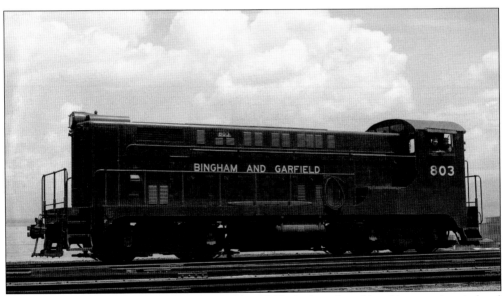

Although the dumper yards were not dieselized in 1942, the benefits of diesel locomotives in local and switching duties became apparent, leading to additional diesel purchases. Three locomotives were delivered in late 1942 and early 1943, including Bingham and Garfield no. 803, a Baldwin model VO-1000, a 1,000-horsepower switching locomotive built in March 1943. No. 803 was sent to Kennecott's Nevada operation five years later, in 1948.

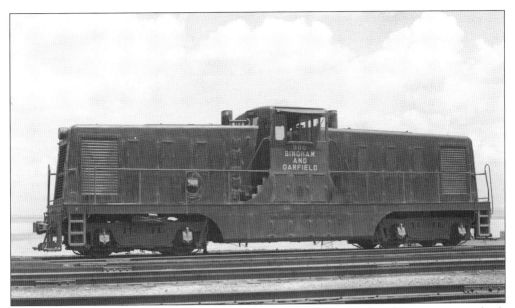

Bingham and Garfield no. 900 was the largest of B&G's four new diesel locomotives in both weight and horsepower. Built by General Electric in March 1943, it weighed 128 tons and was rated at 1,500 horsepower. The locomotive was delivered as B&G no. 802 but was renumbered to no. 900 in June 1943, just three months after delivery.

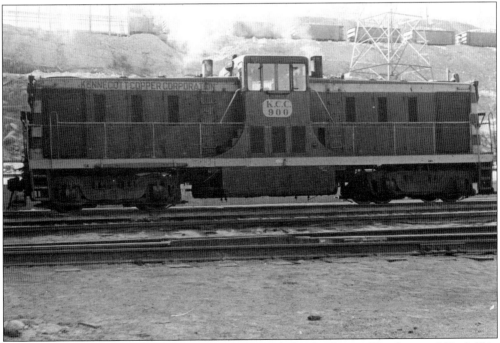

B&G no. 900 was transferred to Kennecott Copper with the shutdown of Bingham and Garfield in 1948. It remained in service until 1969, when it was retired and set aside. The unique locomotive was one of 19 similar locomotives built by GE between 1937 and 1945. After being set aside, it remained at the Magna shop, being slowly dismantled until just its main frame remained by 1972.

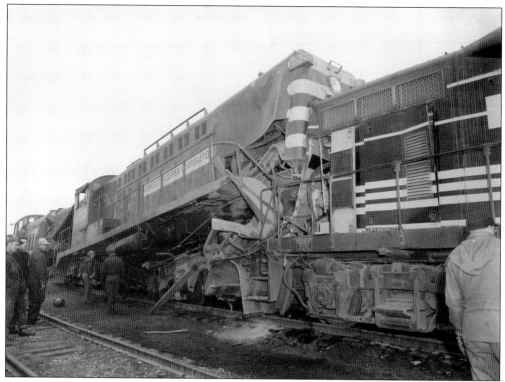

On December 30, 1952, Kennecott Baldwin road switcher no. 901 was moving west through the Magna Yard. No. 901's train was made up of two loads of precipitation copper and no. 902, the road's Alco RS-2. The combination of curved yard tracks, a foggy morning, and a missed signal caused the collision of the Kennecott train with the D&RGW Magna Local, which was just leaving the Magna Yard, heading east.

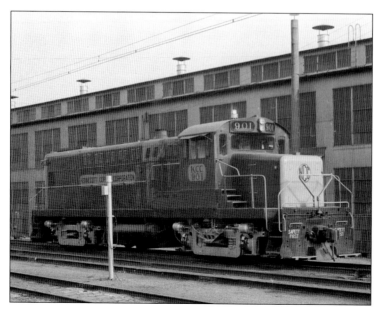

No. 901 was built as a six-axle road-switching locomotive in 1948. The wreck in 1952 damaged the locomotive's front truck assembly. To improve performance, the wreck repairs included a change from six-axle trucks to four-axle trucks. The short hood was cut down in 1972 for better visibility. No. 901 was transferred to the mine in 1977 and renumbered to no. 734. It was retired in 1982.

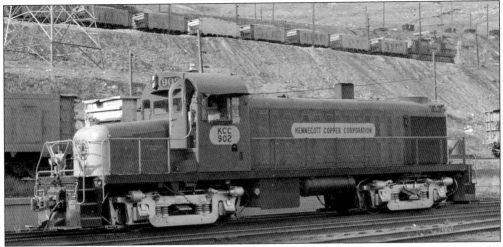

Kennecott no. 902 was an American Locomotive Company model RS-2 and entered service in the Magna Yard on December 13, 1949. In July 1972, the locomotive's high, short hood was cut down to improve visibility. In January 1977, the locomotive was reassigned from its longtime ore-haulage duties to mine operations and renumbered to no. 737. It was retired and scrapped in 1981.

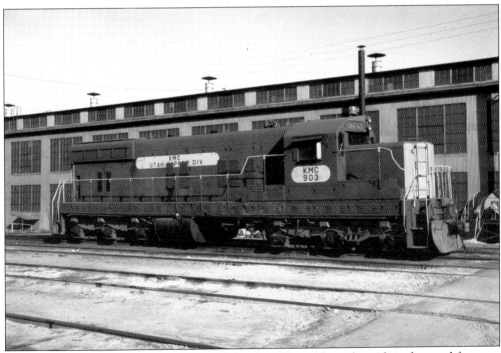

The expansion at the mine that included the 5840 Tunnel brought with it the need for more powerful locomotives in the Ore Haulage Division for local and switching service. Kennecott no. 903 was an EMD model SD7, delivered in December 1952. In 1972, the locomotive's high, short hood was cut down for better visibility. No. 903 was retired in April 1988.

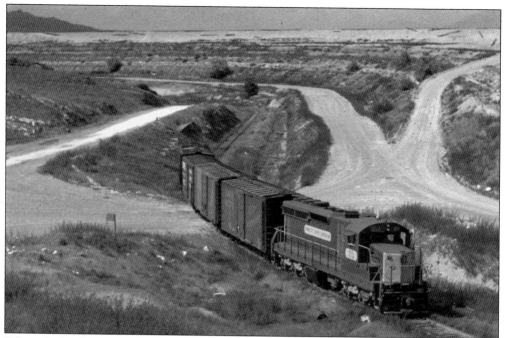

When the Utah Copper mill and the Garfield smelter were completed in 1906, along with the Boston Consolidated mill in 1908, they were connected to the nation's railroad network at Garfield station on Union Pacific. That connection remained through the years and is shown here in June 1971 as Kennecott Copper no. 904 moves a few railcars from Garfield back to the mills. No. 904 was usually assigned this task.

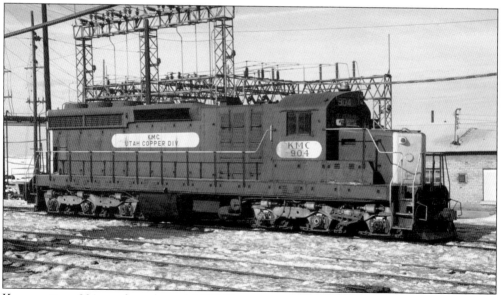

Kennecott no. 904 was the only model SD24 locomotive built by General Motors' Electro-Motive Division in 1963. It was delivered to Kennecott in March 1963. Prior to Kennecott's locomotive, the last SD24 had been built in 1961. Kennecott had wanted a six-axle version of EMD's then-current GP30 model, which was only available as a four-axle version. Kennecott no. 904 remained in active service until it was retired in 1988.

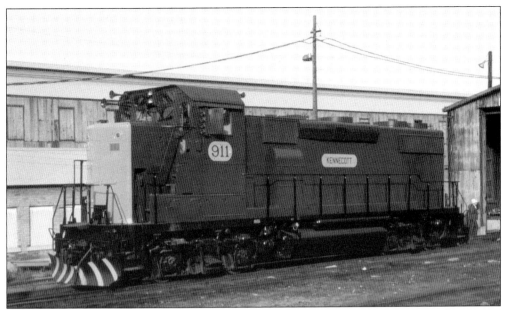

Delivered as one of the 28 unique high-cab GP39-2s, Kennecott no. 911 was built as mine locomotive no. 786 in 1977. It was transferred to Ore Haulage in 1983, repainted from all yellow to green and yellow, and renumbered as no. 911. It was a leased locomotive and remained in active service until returned to its owner in 2005. No. 911 is now Dakota and Iowa Railroad no. 2511.

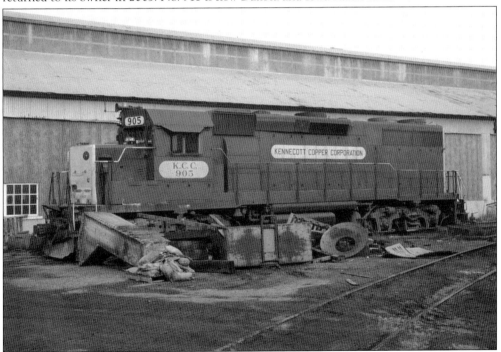

At the same time as the high-cab GP39-2s were delivered to the Bingham mine, Kennecott also received a standard-cab version GP39-2 to add to its ore-haulage fleet for local and switching service. No. 905 was built by EMD in late 1976 and was delivered in January 1977, and it is shown here at the Magna mill in October 1983.

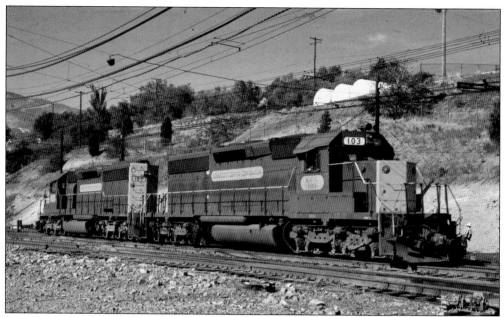

The Copperton Line was completed in April 1948 and continued to operate as an electric railroad until December 1978 when seven new model SD40-2 locomotives entered service. They were built by General Motors' Electro-Motive Division as standard locomotives except for an added air reservoir mounted behind the fuel tank. Nos. 103 and 107 are shown at Copperton in October 1983.

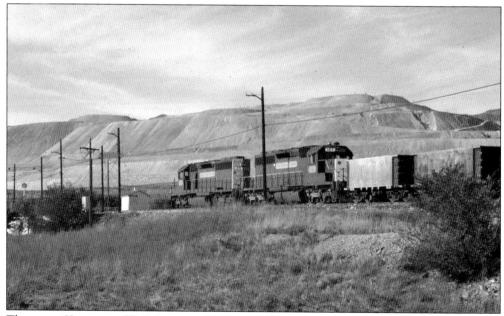

The seven Kennecott SD40-2s entered service in December 1978. The power to the overhead catenary was cut off on January 12, 1979. The SD40-2s remained in heavy-haul, daily service from 1978 to 1984 when they were returned to their owner, Helm Financial. Helm then leased the units to British Columbia Rail in Canada for a period of 10 years, after which they became Helm nos. 6204-6210.

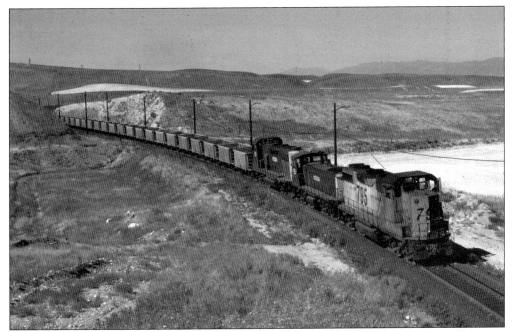

The Ore Haulage Division was shut down on July 1, 1984, but rail operations continued by using crews and locomotives from the mine, moving 35,000 tons per day using a total of 400 ore cars. The SD40-2s were returned to their owner, and the remaining Ore Haulage locomotives, along with a few high-cab GP39-2s from the mine, were used as motive power. This photograph from August 1987 shows an example of the mix of locomotives used after 1984.

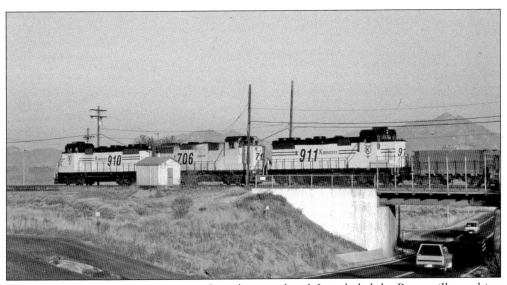

In late 2001, the North Concentrator Complex was closed. It included the Bonneville crushing and grinding mill, which fed the Magna concentrator. This photograph from mid-1992 shows the mix of locomotives being used at the time. Rail operations ended when the North Concentrator closed, with all ore being moved via conveyor belt through the 5490 Tunnel directly to the Copperton concentrator and then by slurry pipeline to the smelter.

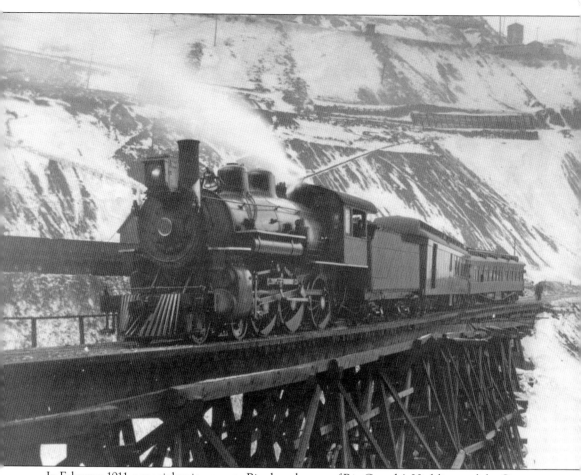

In February 1911, a special train came to Bingham by way of Rio Grande's Highline and the Canyon Bridge connection to the Utah Copper Yard. The occasion was the cross-country honeymoon trip via private railroad train for a party celebrating the marriage of Vivian Gould, daughter of financier George Gould. The private train included D&RGW 4-6-0 locomotive no. 780, with a combination baggage and staff car, and Gould's private car.

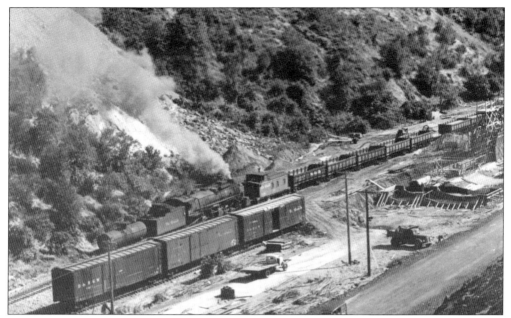

Denver and Rio Grande Western continued to provide rail service to the town of Bingham throughout the 1950s. This photograph from 1945 shows the tunnels being built as part of Kennecott's C-C Line. At the time, there were still active mines in the canyon, including the U.S. Mine in Upper Bingham and the Utah-Apex in Carr Fork. Bingham and Garfield provided local service that interchanged with D&RGW at Copperton.

Rio Grande Western's Garfield Branch extended 16.5 miles from Garfield Junction (later Welby) on the Bingham Branch, to the new copper smelter at Garfield on the Great Salt Lake. Completed in 1905, the new line passed through the site where Utah Copper completed its Magna concentrator mill in April 1907 and included the depot seen in this late-1920s photograph.

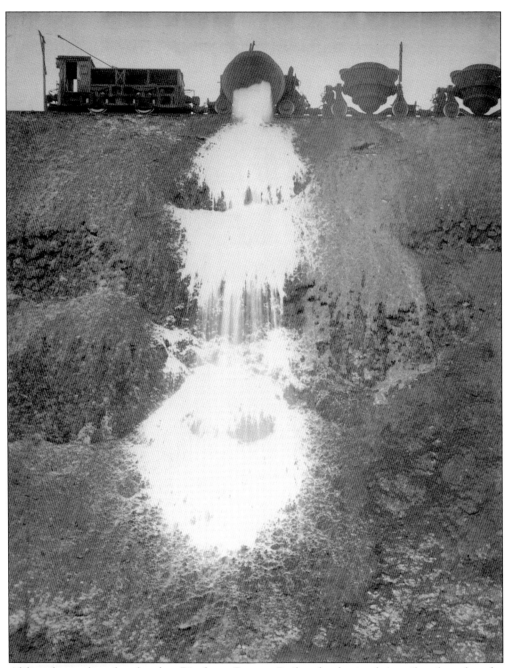

Although not directly related to Bingham Canyon Railroads, the in-plant railroad used at the Garfield Smelter provided a vital service to the production of copper metal. Included was the transportation of molten slag from the smelter out to the slag dump north of the smelter. The molten slag was a dramatic sight during night hours, and it was mentioned in lists of sights to see while visiting the Great Salt Lake.

# *Eight*
# SMELTER OPERATIONS

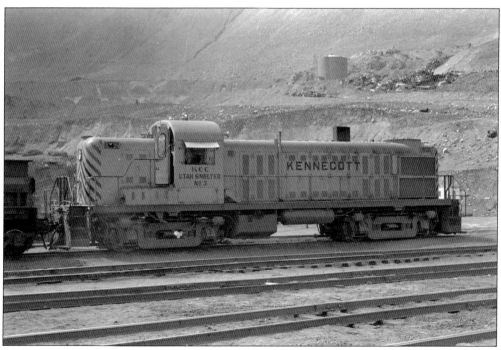

Originally built for the American Smelting and Refining Company in November 1950, Smelter locomotive no. 3 was an Alco RS-3 and became Kennecott Utah Smelter no. 3 when Kennecott bought the smelter from ASARCO in January 1959. Along with no. 2, an identical RS-3, no. 3 remained in service at the Garfield Smelter until replaced by new GP39-2s in March 1982.

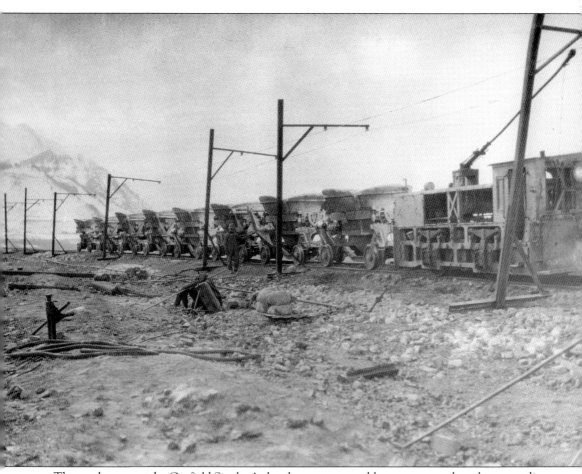

The trackage atop the Garfield Smelter's slag dump was movable to accommodate the expanding dump itself. The overhead wire was on portable supports that could be moved as needed to keep direct access to the edge of the dump. The locomotives on the slag trains were all standard gauge, with some built by Baldwin and others by General Electric.

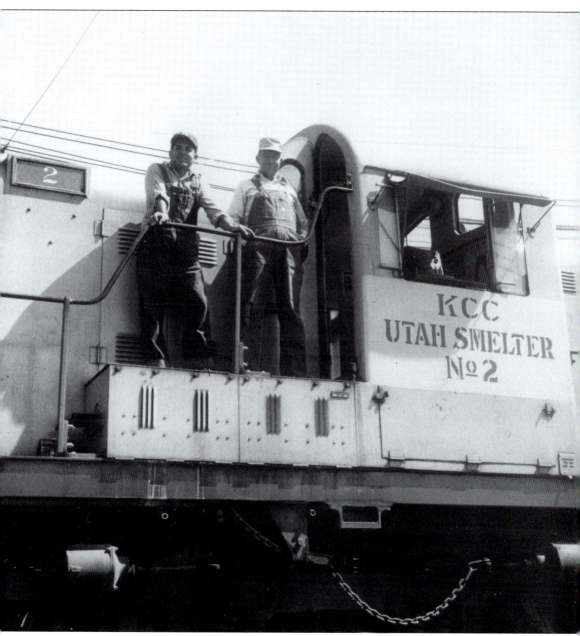

Kennecott's Utah Smelter was completed in August 1906, having been built by the Garfield Smelter Company, a subsidiary of American Smelting and Refining Company. ASARCO continued to operate the smelter until January 1959, when it was sold to Kennecott Copper Corporation. Locomotive no. 2, an Alco model RS-3, arrived in November 1950, replacing several steam locomotives previously assigned to switch the smelter yard where interchange with D&RGW took place.

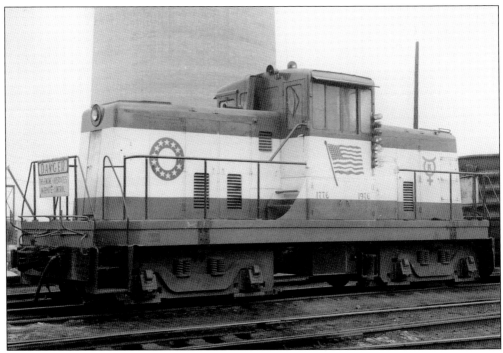

In celebration of America's 200-year anniversary, Kennecott painted its Utah Smelter no. 1 into a commemorative red, white, and blue scheme. No. 1 had arrived at the smelter in July 1949 while the smelter was owned by ASARCO and remained after Kennecott purchased the smelter in 1959. The locomotive was retired in 1983 and sold to Wyoming Rail Car Company in Evanston, Wyoming.

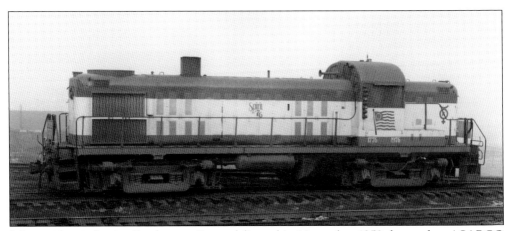

Like its identical twin, Smelter no. 3 was delivered in November 1950, lettered as ASARCO Garfield Smelter no. 3. It became Kennecott's Utah Smelter no. 3 in 1959 and was painted red, white, and blue (like no. 1) in 1975. Both no. 2 and no. 3 remained in service until 1982, and in November 1985 they were donated to the Feather River Rail Society in Portola, California.

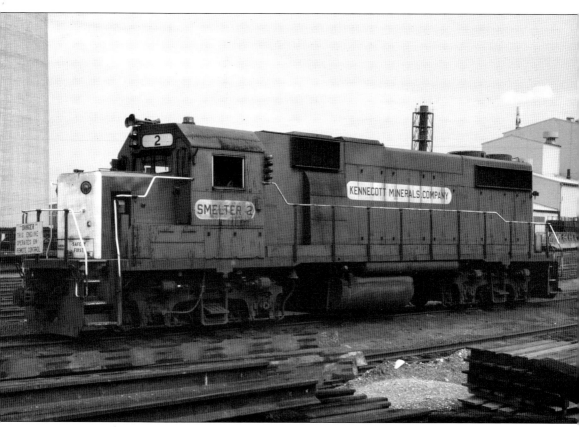

Kennecott Smelter no. SM-2 was a new GP39-2 delivered to Utah in February 1982. It arrived together with SM-1, an identical GP39-2, painted red and white. Because of their dedicated service location (the flat yard at Kennecott's Garfield Smelter), both units lacked dynamic braking and were equipped for remote control. They remained in service at the smelter until returned to their owner, Helm Financial, in 1999.

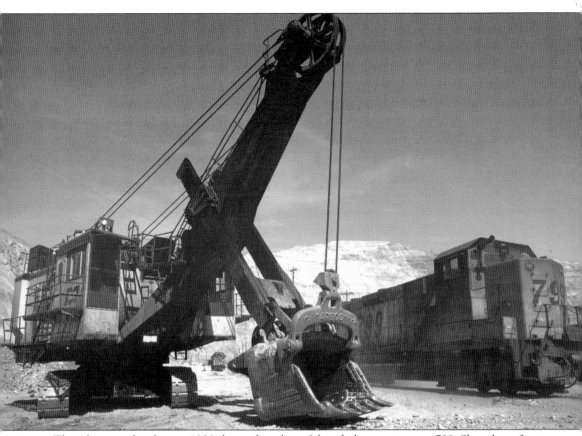

This photograph taken in 1988 shows shovel no. 3 beside locomotive no. 799. Shovel no. 3 was a Marion model 151-M electric shovel equipped with an eight-cubic-yard bucket. In 1953, no. 3 was delivered to the Bingham mine, 25 years before diesel locomotive no. 799, a GP39-2 built in 1978. There were a total of 12 Marion model 151-M electric shovels in the Bingham mine.

# Nine
# TRUCKS AND SHOVELS

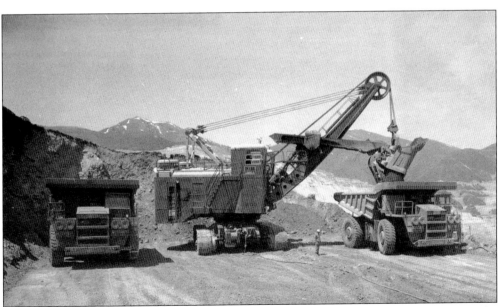

Kennecott shovel no. 35 is shown loading truck no. 494 while truck no. 498 waits its turn to be loaded. Truck haulage began in November 1963 after the delivery of a fleet of trucks with 65-ton capacities. Within a year, trucks with 85-ton and 110-ton capacity were added. On May 13, 1968, a daily haulage record of 298,454 tons of material was set.

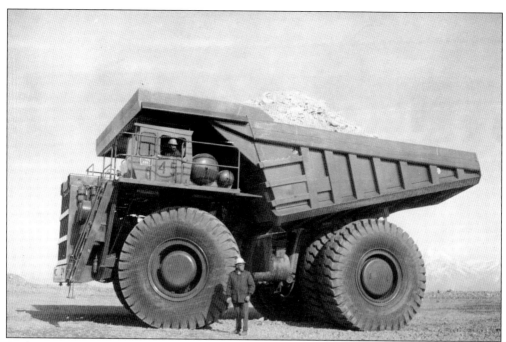

By the time truck no. 451 was delivered in July 1981, haulage trucks had been in use at the Bingham mine for almost 20 years. No. 451 was rated at 150 tons of waste material and was among a group of 18 Haulpak trucks delivered in 1981 by Westinghouse's Wabco Division.

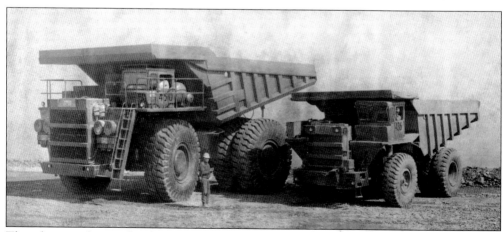

This photograph provides the opportunity to compare the newest 150-ton haulage truck, no. 450, delivered in mid-1981, with the older, 65-ton capacity model, no. 436. Both were built by the Haulpak Division of Westinghouse Air Brake Company, also known as Wabco. The Haulpak 65-ton model was among the first haulage trucks delivered to Kennecott in 1963.

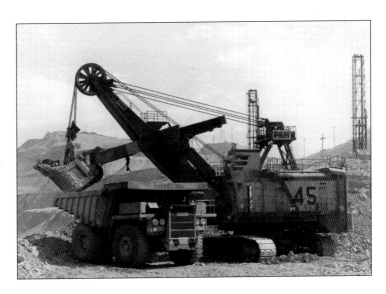

Shovel no. 45, a P&H model 2800 with a 27-cubic-yard dipper bucket built in 1977, loads truck no. 335 in this August 1981 photograph. Truck no. 335, a Haulpak model M-36, was built in 1974 and has a rated capacity of 150 tons. The large shovel capacity, together with large truck capacity, helped make the Bingham mine one of the world's most productive mines.

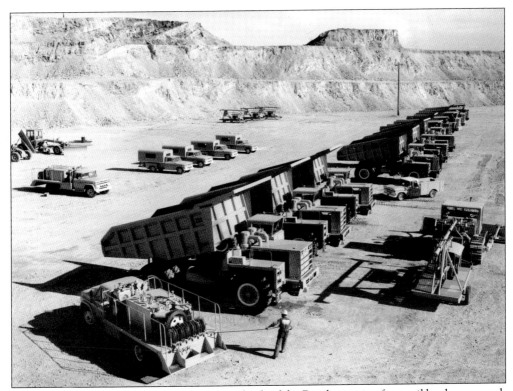

In 1963, Kennecott converted the upper two-thirds of the Bingham mine from rail haulage to truck haulage. Some of those first trucks are seen here in this photograph taken at the newly completed Yosemite shops. The trucks closest to the photographer are new KW Dart 65-ton trucks. A bit farther back in the row of trucks, a few of the new 65-ton Haulpaks have been lined up.

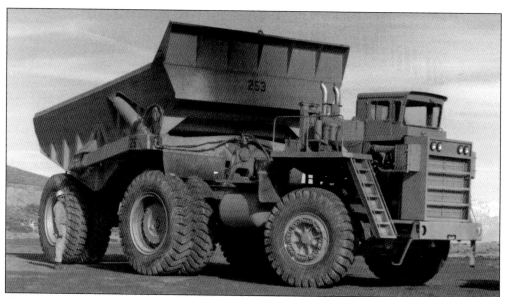

Truck no. 253 was a KW Dart articulated rear-dump haulage truck built in 1963 with a rated capacity of 110 tons. They were some of the largest haulage trucks built at that time and were used at Bingham to move waste rock to the Yosemite and Castro dumps. The drivers and mechanics knew these trucks as "artics," a shortened name for their articulated configuration.

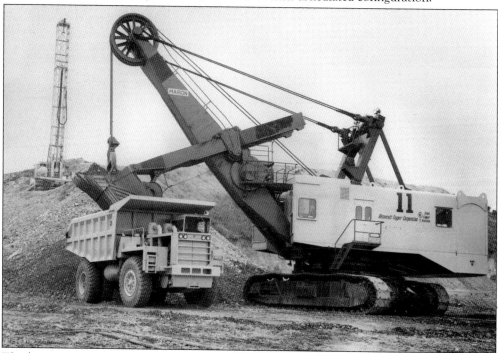

The $100 million expansion begun in 1963 was intended to increase ore production from 90,000 tons per day to 108,000 tons per day. To mine the ore, very large quantities of waste rock needed to be removed. New equipment was added for the expansion, including four new electric shovels, two with 12-cubic-yard dippers and two with 15-cubic yard dippers, including shovel no. 11, shown in this September 1963 photograph.

A Marion model 191-M electric shovel loads truck no. 451 in this undated photograph. The 191-M shovels all arrived in the late 1960s and early 1970s. Truck no. 451 was delivered in 1981 and had a rated capacity of 150 tons. The Marion 191-M shovels all had a dipper capacity of 15 cubic yards. This combination of shovel and truck was used exclusively for waste removal.

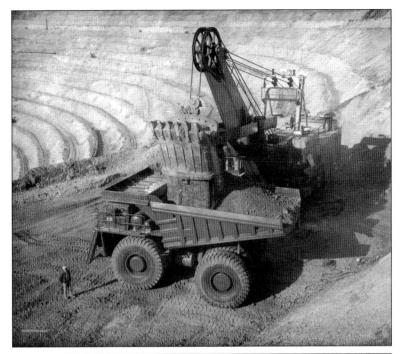

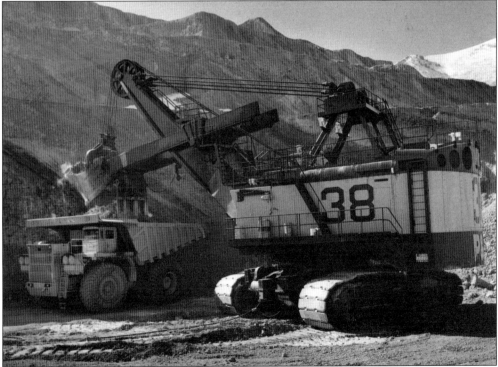

The largest-capacity trucks and shovels were assigned to waste-rock removal. The next generation in growth for shovel and truck capacity is shown in this photograph of shovel 38 and truck 319. Shovel 38 was a P&H model 2800 with a 27-cubic-yard dipper, built in 1975. Truck 319 was a LectraHaul model M-36 with a 150-ton capacity, built in 1973.

Basil Doman was a locomotive engineer at the Bingham Canyon mine. During World War II, he began building scale models, measuring the locomotives and ore cars he worked with every day. He is shown here with a 1:48 scale model of electric locomotive no. 761, which he operated daily, along with a 1:96 scale model of one of Kennecott's newest Marion electric shovels.

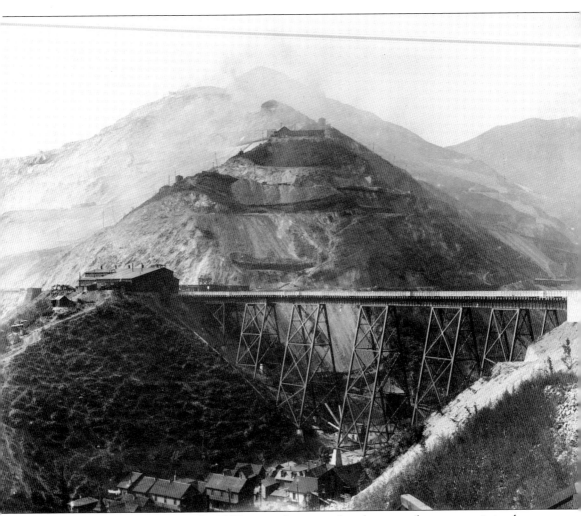

This 1914 photograph shows "The Hill" just eight years after the start of open-cut mining by Utah Copper and Boston Consolidated. The old Boston Con workings are at the top, with Utah Copper's workings to the left. Carr Fork, with its underground workings, is to the right. Today, "The Hill" is literally gone, having been replaced by the largest excavation on Earth.

# www.arcadiapublishing.com

Discover books about the town where you grew up, the cities where your friends and families live, the town where your parents met, or even that retirement spot you've been dreaming about. Our Web site provides history lovers with exclusive deals, advanced notification about new titles, e-mail alerts of author events, and much more.

Arcadia Publishing, the leading local history publisher in the United States, is committed to making history accessible and meaningful through publishing books that celebrate and preserve the heritage of America's people and places. Consistent with our mission to preserve history on a local level, this book was printed in South Carolina on American-made paper and manufactured entirely in the United States.

This book carries the accredited Forest Stewardship Council (FSC) label and is printed on 100 percent FSC-certified paper. Products carrying the FSC label are independently certified to assure consumers that they come from forests that are managed to meet the social, economic, and ecological needs of present and future generations.

**FSC**
**Mixed Sources**
Product group from well-managed forests and other controlled sources

Cert no. SW-COC-001530
www.fsc.org
© 1996 Forest Stewardship Council

**Find Your Place in History.**